Family Portrait Photography

By Helen T. Boursier

AMHERST MEDIA, INC. ■ BUFFALO, NEW YORK

Dedicated to my mother, Diane, who always
expected me to perform at my absolute best.

SO PH CCC

Copyright © 1999 by Helen T. Boursier

Published by:
Amherst Media, Inc.
P.O. Box 586
Amherst, NY 14226
Fax: (716) 874-4508

Publisher: Craig Alesse
Senior Editor/Project Manager: Richard Lynch
Associate Editor: Frances J. Hagen
Copy Editor: Paul Grant
Image Technician: John Gryta

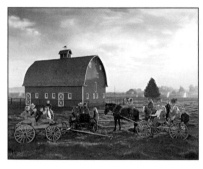

Cover photo by Ken Whitmire.

ISBN: 0-936262-75-3
Library of Congress Card Catalog Number: 98-72909

Printed in the United States of America
10 9 8 7 6 5 4 3 2 1

Table of Contents

CHAPTER ONE

An Overview . **5**
　　The History of Family Portraiture 5
　　Today's Family Portraits . 6

CHAPTER TWO

Getting the Business to Come to You **13**
　　Marketing Family Portraiture 13
　　Creative Promotions . 17

CHAPTER THREE

Preparing Your Subjects . **25**
　　Advance Planning . 25
　　Clothing . 26

CHAPTER FOUR

Portraits Require People Skills **32**
　　Portrait Psychology . 32
　　Working with Different Ages 32
　　Using Your Personality to Get the Right Shot 38

CHAPTER FIVE

A Matter of Style . **40**
　　Creating Your Style . 40
　　A Variety of Styles . 42

CHAPTER SIX

Packing Your Camera Bag . **50**
　　Camera Selection . 50
　　Equipment List . 51

CHAPTER SEVEN
Props . **56**

CHAPTER EIGHT
Studio Posing & Lighting Techniques **64**

CHAPTER NINE
Photographing on Location **71**
 Checking a Location . 71
 Light & Composition . 71
 Fill Flash versus Available Light 79

CHAPTER TEN
Photographing at Your Client's Home **83**

CHAPTER ELEVEN
Presentation Options . **93**
 Contact Sheets . 93
 Paper Previews . 93
 Opaque Projectors . 93
 Slide Proofs . 94
 Video Projection . 95
 Digital Projection . 96
 The Finished Product . 97
 Types of Products to Offer 97

Appendix . **100**

Glossary . **104**

Index . **106**

"The quality and variety... will set the mood to create desire."

Chapter One

An Overview

Family portraiture is one of the most overlooked areas of professional photography. Photographers don't know how to motivate potential clients to come in for a family portrait session, and families often don't feel any desire or need to come in on their own. Education is the key to breaking this "Catch-22." First you must show clients why they should desire a family portrait, and then you can help them to justify why they need one. The quality and variety of your images will set the mood to create desire.

The History of Family Portraiture

The misconception about family portraiture begins in our history books and in our museums. Today's family portraiture has little to do with the stiff images recorded a century ago. Those images were taken with large format cameras, slow film and limited light. Photographers had to use very long exposures, and subjects were often literally strapped into the posing chairs so they could and would not move. At the very least, they had to hold completely still.

The end result recorded what the family looked like, but not the feelings behind the stiff expressions. When you are not familiar with professional photography, you will not necessarily know the limitations the early photographers had in recording those first family portraits. Instead, through history books and museums, you are repeatedly reminded that family portraits are stiff and formal. Stiff and formal are not what today's family wants.

Church directories and chain store promotions led the next phase of family portraiture. It was inexpensive and convenient for families to go to these places and get a portrait. The end product was a bit more modern than what the portrait pioneers created, but the results were usually formal, posed pictures with flat lighting and a generic blue background. The photographs again showed what the family looked like, without portraying the feelings behind the faces.

The next era of family portraiture evolved out of the wedding photographer moving from photographing wedding formals only at the

1-1: Family portraiture on location evolved from the wedding photographers who first pursued photographing the bridal party at the church or reception instead of the traditional studio setting. Photo by Horace Holmes.

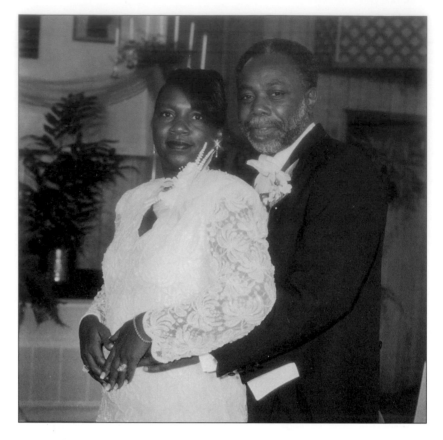

studio, to going on location to the church and the reception facility. Candid wedding coverage became the norm, and studio formals became almost a thing of the past. Brides enjoyed the personal element of being photographed in their own home, at their church and at their reception facility. Families also enjoy the same choice.

Today's Family Portraits

Family portraiture in the year 2000 is finally following the lead of what the wedding photographers started in the 70s. The studio is now only one of many location choices for family portraiture.

Today, more and more families are choosing to have their portrait created at a location which holds special meaning for their family. It might be in or at their home, at a favorite vacation location, or with a prized possession (i.e. boat, car or motorcycle) which represents fun family time or the pride of a landmark personal accomplishment. Location is one part of the changing family portrait equation, and the actual motivation for commissioning a portrait is another.

Ed Lilley of Harwich, Massachusetts, a portrait photographer for almost thirty years, said he has seen a change from why families come to his studio for family portraits. He said they used to come in because it was tradition to have a family portrait created. Today, the two key reasons are pride and the documentation of family growth.

Ultimately, parents want family portraits for one key reason — to remember. And to remember not just the faces, but the laughter and the fun and the triumphant moments.

"Location is one part of the changing family portrait equation..."

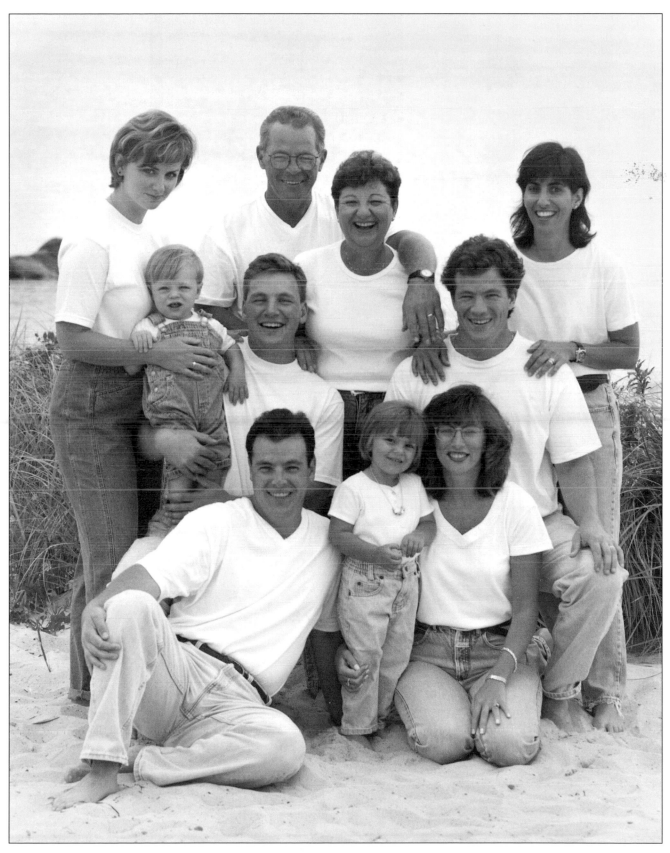

1-2: *Today's family portraits are more relaxed than the photographs you see in museums or history books. They reflect the personality of the family unit as well as each of the family members. Photo by Helen T. Boursier.*

1-3: When the mother first saw this image, she said, "That's us!" Of the sixty or so choices she had, this is the pose she chose to send to family and friends with her Christmas card because she said it captured her family in action. Photo by Helen T. Boursier.

•**Mothers, who see their children growing up too fast, are typically the ones who call your studio regarding a family portrait.**

Portraits remind you not only of what family members looked like at a given age, but what they did, what they said, what their favorite outfits were and what made them laugh. Photographs also remind us of the great love and the great joy we share as a family.

The telephone call to inquire about a family portrait most commonly comes from the mother. All of a sudden she looks at her little baby boy and realizes he is quickly losing his baby fat. She wants a family portrait to capture that "baby" before he is gone forever.

Another mother calls because her once wild two-year old is suddenly a five-year-old starting kindergarten and, "I don't know how she got so big so fast."

Another panicky phase comes when mom realizes her first or second grader is about to loose the top front teeth, representing the onset of the much older "big teeth" phase. Some mothers want a portrait before preteens have their braces put on, other moms as a memory of the "braces" age itself, and still other mothers want a portrait as soon as the braces are finally removed.

High school graduation is a key life-changing time that prompts many mothers to schedule a family portrait session. On one hand, parents are

1-4: My family reunion sessions always begin with photographing the entire group until I am satisfied I have an image they will love. Photo by Helen T. Boursier.

1-5: These sessions always include a grouping of what I call the "blood," mom and dad with the immediate siblings. Photo by Helen T. Boursier.

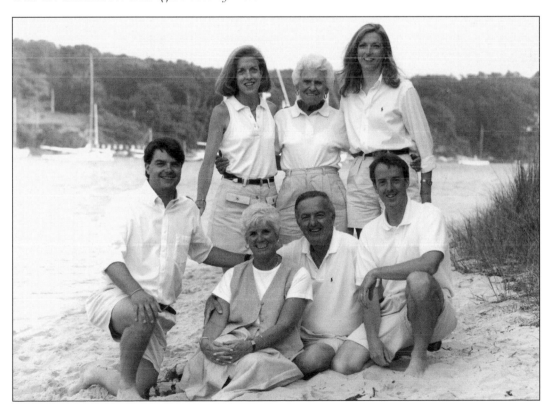

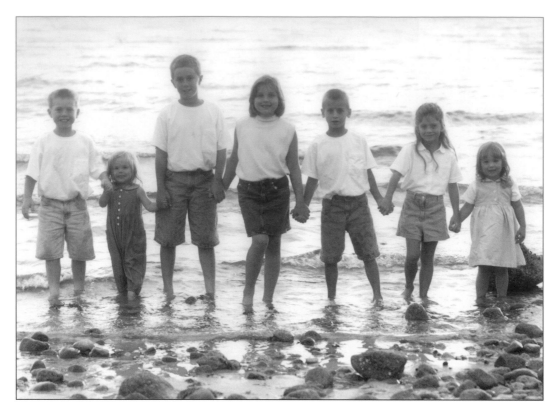

1-6: *Another must-do is a "cousins" photograph. I particularly like taking an image that shows the various heights of all the children. Photo by Helen T. Boursier.*

1-7: *New Hampshire photographer Jay Goldsmith created a portrait that reflects that travel is an integral part of this family's lifestyle. Photo by Jay Goldsmith.*

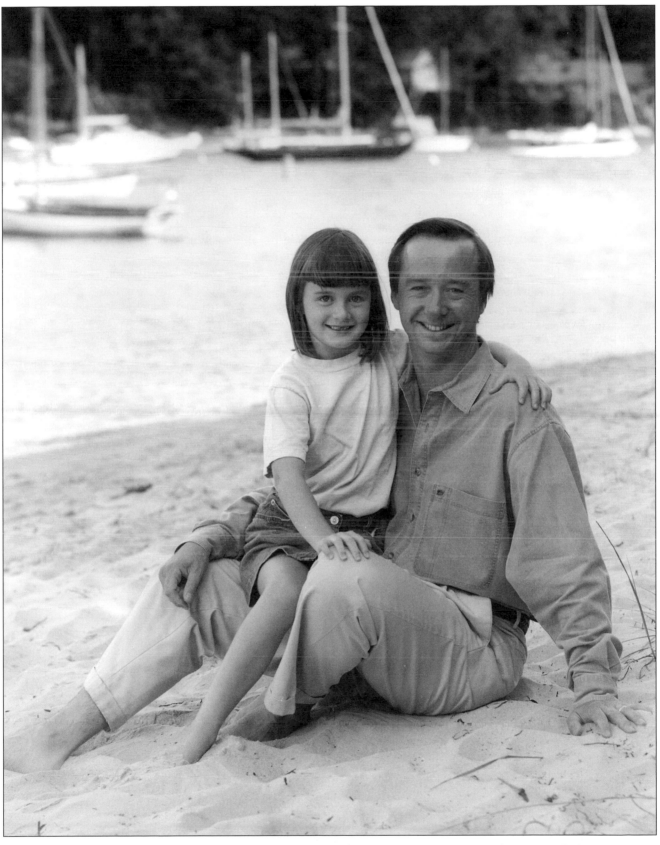

1-8: *Family portraits are about relationships. This father-daughter portrait captures the special feeling these two people share for each other. Photo by Helen T. Boursier.*

proud of their child's growth and maturity and, on the other hand, they have no idea how the time passed so quickly.

College graduation marks another important time line that prompts clients to call. From that point forward, the family gatherings become less and less frequent, so times spent as a family group become more and more cherished.

The gathering might be for a family wedding, an anniversary celebration, a landmark birthday, or to christen the new grandchild. Whatever the occasion for the gathering, the fact that a family is all under one roof for the first time in many years is reason enough to capture the moment with a portrait.

Today, family portraiture is not about recording eyes, ears, nose and teeth. It is about capturing the very heart and soul of the family. The viewer should be able to look at the image and gain a sense of the feelings and relationship behind the faces.

The message photographers must take to potential clients is that family portraits freeze frame a slice of our lives and remind us why we live, why we work, and why we love our families. Once you understand the emotional elements behind a family portrait, you can target marketing to transform that emotion into action.

1-9: High school graduation is a landmark time for every family because it represents the end of an era. With the local marina of their summer residence as a backdrop, the teenage boys served as a wind block to keep the blustery winds from blowing their mother's hair. Photo by Helen T. Boursier.

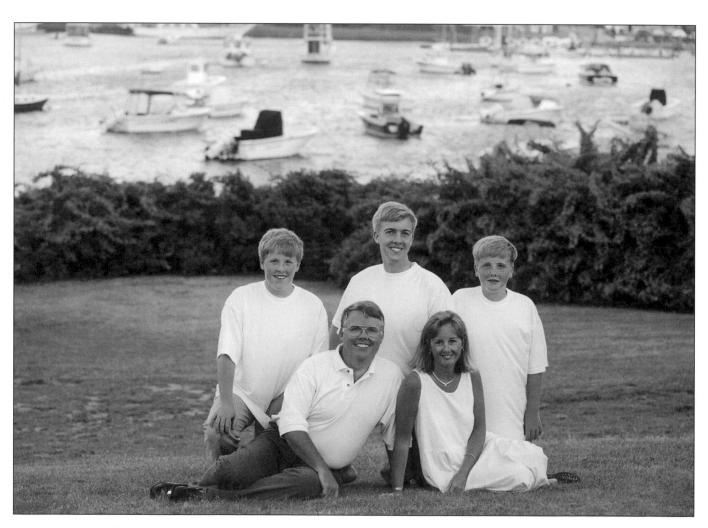

2-1: Whitmire and Wolfe's promotion strategy is based on selling the concept of portraits as wall decor.

CHAPTER TWO

Getting the Business to Come to You

Educating clients about the quality, variety and style of your family portraiture is the first step to creating desire for ownership. Marketing transforms that desire into action.

Marketing Family Portraiture

Yakima, Washington photographer Ken Whitmire began marketing the desire for wall portraits thirty years ago. His passion for family portraits as wall decor overflows into every aspect of his marketing.

Whitmire and Wolfe promote the concept of portraiture as wall decor rather than portraiture itself. Their displays and printed materials show how wall portraits enhance the client's home.

He suggests using more "institutional ads" which market the concept of portraiture as wall decor in general, without specific taglines for prices or promotions. "The milk mustache ads didn't tell you which brand of milk to buy. They just told you to drink milk," he pointed out. Photographers must first market the concept of family portraiture as wall decor. Since the general public can only desire something that they are aware of, Whitmire's favorite "promotion" is a high quality display at a public location like a mall or bank. "I want clients to see the possibilities of this great profession," he explained.

Boursier Photography marketing takes the "show and tell" display one step further. We use a tangible promotion to give clients a specific reason to call the studio and schedule their family portrait. Regardless of where we do the display, the common denominator is the fact that everybody loves a freebie.

Some people hate to use the word "free" with any promotions. However, free offers can be very successful. The key is using marketing (in our case a portrait display) to build the desire and then using the freebie to prompt the action. The freebie is a win for the client because she has a risk-free chance to try our portraiture, and it is a win for the photographer because it prompts the client to stop procrastinating.

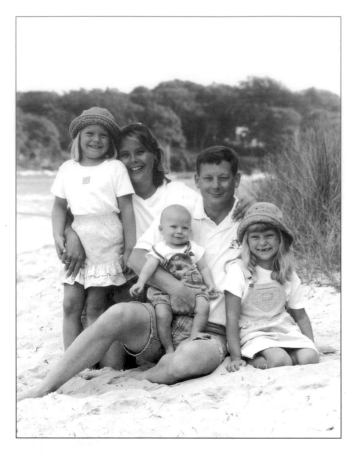

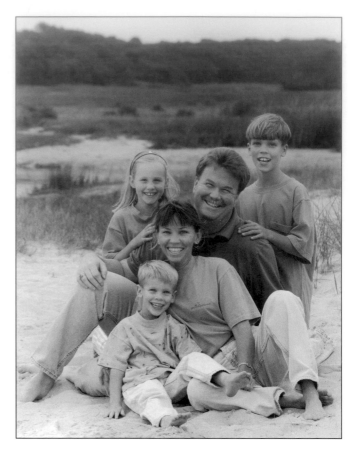

2-2 (left): This family had a certificate for a free portrait session from certificates we donated to the local hospital to include in the "congratulations" baskets given to mothers of newborns. Photo by Helen T. Boursier.

2-3 (right): This family was one of a dozen second place winners in the annual drawing we have at the Falmouth Arts and Crafts Fair. They won a free weekday session and a black and white 8x10 portrait or $100 off any hand colored portrait. Photo by Helen T. Boursier.

We use several variations of freebies with our promotions. When we do a display at an art fair or home show, we conduct a drawing for a free session and an 11x14 hand colored black and white family portrait. Second place winners receive a free session and an 8x10 classic black and white family portrait. Winners are notified with a hand written postcard. The sessions are valid at a choice of four locations over a six to eight week period.

You can also use the sample session and free 8x10 to support various non-profit organizations. Over the years, we have helped to raise thousands of dollars for a wide range of charities from churches, pre-schools, alumni groups that support scholarships and public school volunteer groups to health care organizations like Hospice of Cape Cod and the American Red Cross.

The donated session and 8x10 generate the most money for the fundraiser when they are included in a live auction. We are usually contacted to support a particular group by a client who then brings her actual framed portrait to the auction to help generate interest and make the bidding lively. We also offer certificates for a free sitting and free 8x10 as part of a specific "family portrait fundraiser."

For example, we support the Falmouth Volunteers in Public Schools at its annual home and garden show. With a $30 donation, payable directly to the volunteer organization during the two-day show, we will donate a free sitting and 8x10. The session is valid for two months at one of four outdoor Falmouth locations. The client chooses the favorite

pose for the free 8x10. She may apply the regular price of that size toward a wall portrait purchase.

It is an excellent "promotion" because everyone wins. The organization gets a great fundraiser, the client supports a worthy cause and saves money on something they have been thinking about doing for a long time, and Boursier Photography gets a calendar full of portrait sessions.

We also use the free sitting and free 8x10 concept to do practice sessions on current clients. Every spring I attend photography workshops on posing, lighting, composition and design. My head gets filled with incredible ideas that I can't wait to put into practice, so I ask a few clients if I may do a practice session. It is the old "use it or loose it" concept. I don't think it is right to practice on paying clients, so I offer a free session and free 8x10 or $200 off anything else. I get to put my new ideas to immediate use, and the client gets the benefit of having inspired and creative portraiture.

I offered a similar promotion for a handful of clients when I was working on the final phase of my Master of Photography degree from the Professional Photographers of America. I was a few "merit" prints

> "...use the free sitting and free 8x10 concept to do practice sessions..."

2-4: "Going fishing" was the theme for this merit print project. Photo by Helen T. Boursier.

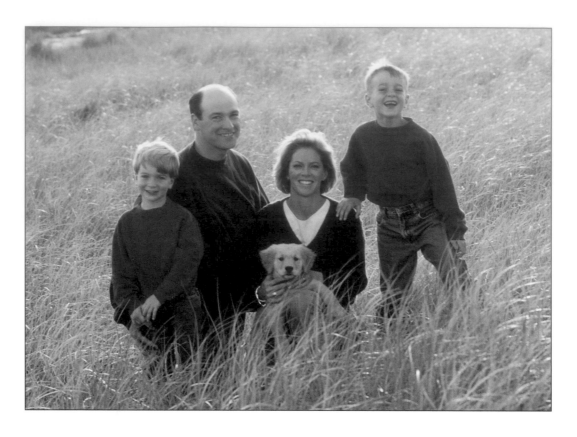

2-5 and 2-6: While I was working on my "merit print project," I created straightforward images typical of my style for the client (above), but I also created more illustrative images for myself (below). Photos by Helen T. Boursier.

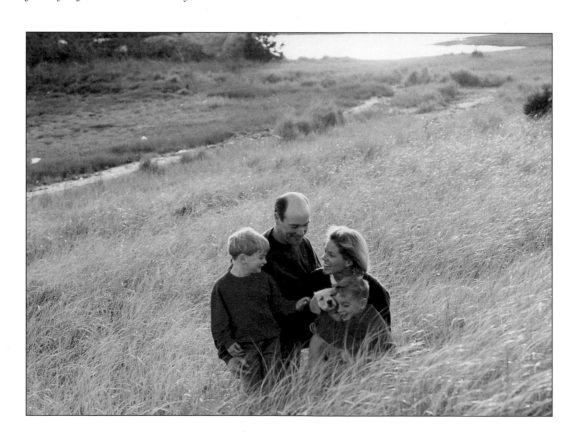

short of the degree. I invited a few clients to participate, and I created story-telling color images that I would ultimately submit in the print competition. My clients enjoyed helping, and I was pleased to earn the Master of Photography degree.

The important point to note is that you must treat each session like it is a paid sitting. Throw all of your energy and enthusiasm and skill into every session, whether paid or free. There is no obligation for any of the free sittings to purchase anything. However, you can tell people right up front that you are going to do such a good job that they are going to want to buy something. They will never have to, but they will always want to. After all, if I don't create beautiful images that they want to buy, then I have no business being a portrait photographer in the first place.

•Be professional and enthusiastic with every session — even if it is a promotional or free sitting.

Creative Promotions

Michelle Schmidt of Hamel, Minnesota offered a "Portraits in the Park" promotion to get her studio clients to do family portraits outdoors. She charged her normal studio sitting fee to do the location sitting, and she included a complimentary 5x7 portrait.

The promotion allowed families to save money on the outdoor session and also get an actual product (the 5x7). "Our purpose was to introduce the concept of going to the park. We wanted to create more artistic poses and storytelling activities like picnics and going for walks."

2-7: This is a flyer for Schmidt's "Portraits in the Park" promotion.

PORTRAITS IN THE PARK
"Imagine your family taking a walk on the beach
or casually sitting among the trees or flowers
enjoying the beauty of nature together."

MICHELLE'S STUDIO
will create that special family portrait for you
at
Parkers Lake in Plymouth

FAMILY SPECIAL
1 - 5X7 Portrait plus session $45
($100 value)

All sessions must be taken by June 30th

Call now to reserve your time!
(Limited Sunday & evening sessions available)
478-9851

Your friends & neighbors are welcome too!

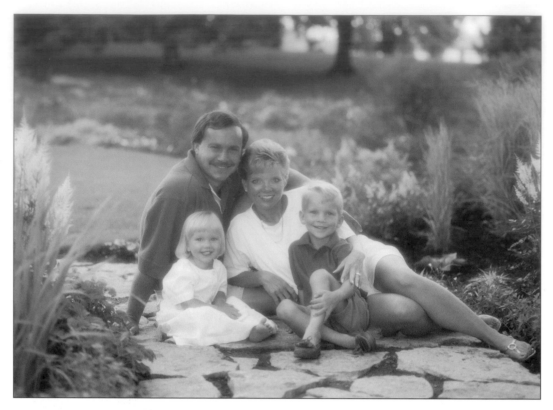

2-8: Choosing a park with a variety of settings that can be used as the light changes throughout the day is an important factor. Photo by Michelle Schmidt.

2-9: There are no restrictions for the size of groups allowed in Schmidt's "Portraits in the Park" summer special. Photo by Michelle Schmidt.

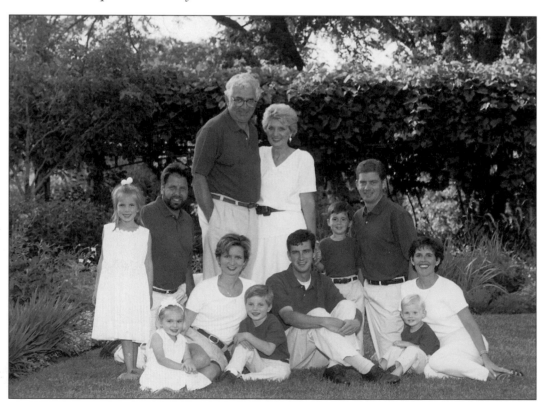

She chose a park with a variety of settings including gardens, walkways, trellis, path, gazebo, boulder walls and a sandy lakeside. This gave her variety plus flexibility for all kinds of lighting conditions throughout the day. This idea is included in Eastman Kodak's *Ideas That Work Volume III*.

A studio in Texas has a variation between "Portraits in the Park" and our portrait fundraiser. To reach out to towns surrounding her rural studio, Charla Holmes of Corsicana schedules a day-long shoot in each of half a dozen towns. Originally, for $20 plus a toy to be donated to the local Toys for Tots program, she offered a twenty to thirty minute photography session and a free 8x10. Sessions were available on a first-come basis by appointment from 9 a.m. to 4 p.m. on a designated Saturday or Sunday during October.

The morning of the shoot, she loaded up her vehicle at 7 a.m. with whicker strollers, bushel basket full of apples, pretty benches, and all kinds of chairs and little props. She brought three assistants to make sure things ran smoothly. The only time these clients had to visit her studio was the view the original images and make their selections.

On one occasion she drove as far away as Houston (200 miles) to photograph on the property of a special client who moved from

2-10. Charla Holmes talks with clients over the phone to help them decide the best clothing for the location. They are also welcome to come to the studio. Photo by Charla Holmes.

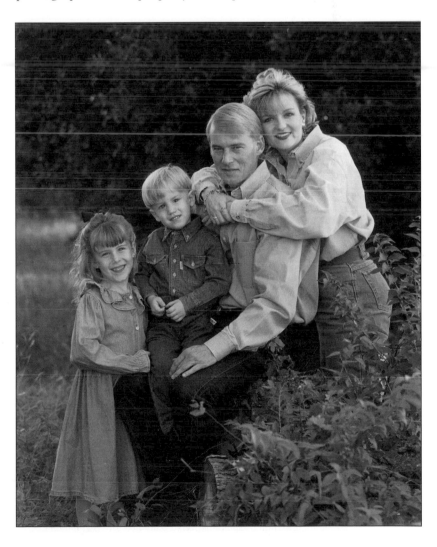

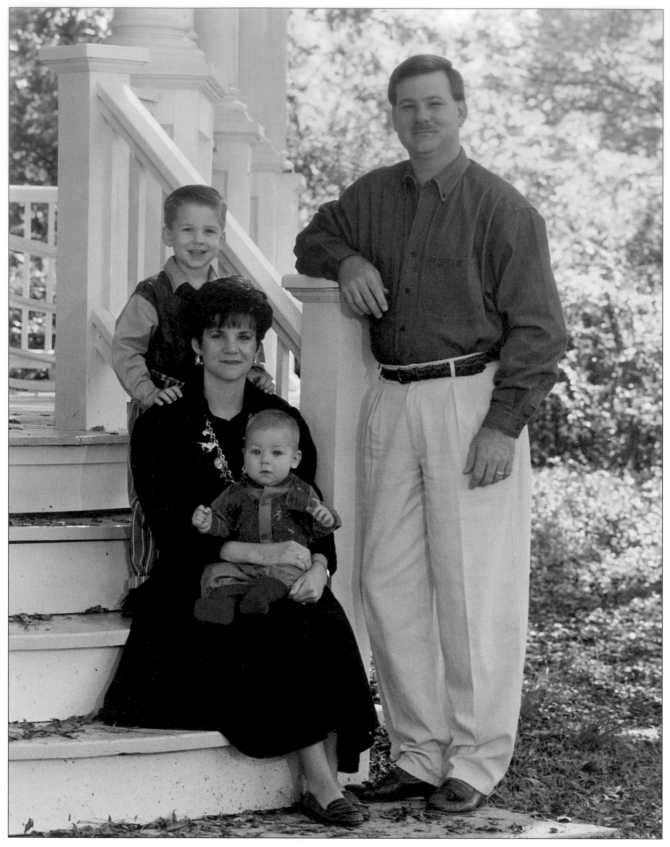

2-11: Porches offer a shady mid-day location to photograph in soft light. The porch also serves as a natural prop. Photo by Charla Holmes.

Corsicana to Houston and wanted the family photographer to move with her!

The client rounded up her friends and actually scheduled the portrait sessions at the regular session fee. Holmes ships all the proofs to her client's home to arrive on a Wednesday, and the new clients come pick them up.

Then she goes back to her client's home with her opaque projector to help clients make decisions on which poses to purchase in which sizes. "It is real easy to show clients what works the best because her home is filled with all the portraits I've done of her boys through the years. I can just go right to her walls to show different sizes. We even sell frames so the portraits are complete and ready to hang," she explained. In exchange for coordinating all the sessions, Charla does a free session and free 16x20 portrait for her hostess of her sons.

Cape Cod photographer Ed Lilley offers a summer promotion for his beach portrait clients during July and August and a studio promotion in December for local patrons.

The majority of his summer sessions are booked as a direct result of seeing his work on display at the summer arts fairs. He said when people look at a framed portrait on display, they want to know "How

"...help clients make decisions on which poses to purchase..."

2-12: Pricing your portraits to include the sitting fee, the portrait, and the frame makes it easier for clients. Photo by Ed Lilley.

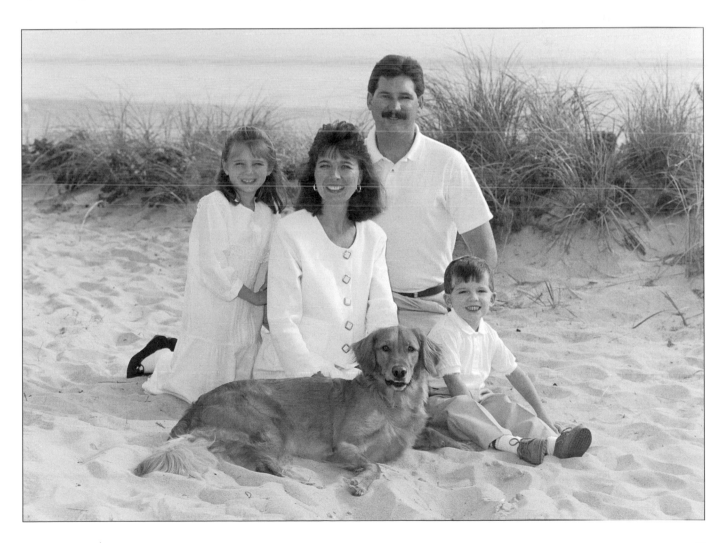

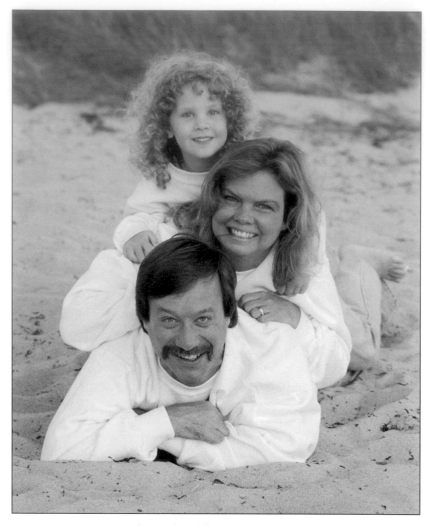

2-13: *Family pride is what brings clients to E.R. Lilley photography for a portrait. Photo by Ed Lilley.*

•**The one all-inclusive price concept is easier for both the studio and the client.**

much?" Instead of confusing them by quoting separate fees for the sitting, the portrait and the frame, he quotes one all-inclusive price. The "promotional" price is based upon the regular family portrait price list, but the frame is thrown in at no charge. He said the one-price concept makes it easier for the studio to quote prices and easier for the client to purchase.

He targets his winter promotion to year-round clients who want gift sizes and Christmas cards. "The differences between a promotional session and a regular session are time and service. The promotional sessions are convenient, quick and inexpensive. In return, they get less time and less service," Lilley explained, adding, "Our normal sittings in the summer include a lot more time and effort with a clothing consultation and going on location. The people who come to the studio for the promotional sittings wouldn't do our regular summer sessions, and the summer clientele wouldn't come in for the promotional sitting because they don't want a portrait session in the studio."

Marshall, Michigan photographer Dennis Craft said the best way to photograph more families is to photograph more children. "If you build a children's portrait market, you will do more families than you could

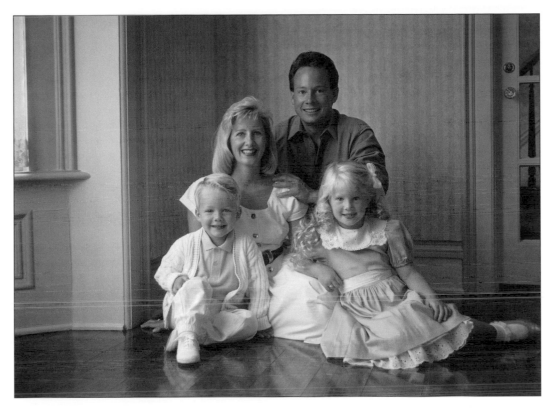

2-14: *Photographer Dennis Craft believes that the more children you photograph, the more family portrait business you'll get. Photo by Dennis Craft.*

2-15: *Dennis Craft said he built his children's market up, and his family portrait business nearly doubled in a matter of just two years. Photo by Dennis Craft.*

ever hope to do. People who are interested in having family portraits done all have children," he said.

Randy Taylor of Edmond, Oklahoma built his family portrait business by tying in with local holiday home tours. He proposed the sponsor make it mandatory for him to photograph each participating family. Then he created a 20x24 portrait to be displayed inside the front entrance of the home as a silent "welcome" to the visitors.

2-16: Randy Taylor used local holiday home tours as a way of building up his family portrait business. Photo by Randy Taylor.

CHAPTER THREE

Preparing Your Subjects

"A beautiful family portrait is not something that just happens."

A beautiful family portrait is not something that just happens. It gradually evolves. The more you help your client visualize the portrait in advance, the better prepared they will arrive to the portrait session. You will then be able to do a much better job, and they will enjoy the end results that much more.

Advance Planning

The advance planning may take the form of a telephone consultation, a printed packet of information outlining detailed information or a planning or design session at the client's home or your studio. Some studios rely on one of these choices, and others use all three.

The information you need to cover includes clothing dos and donts, portrait style, names and ages of the subjects, location choices, studio prices and policies, and any special information relating to each particular family (i.e. grandfather deceased and grandmother remarried).

At Boursier Photography, I start the planning process over the telephone. Most of my clients are summer residents who actually live one to five hours away. I offer the option of coming in for an in-person planning session, but it is just not practical for the majority. Therefore, I created a packet of planning information which explains most of the information noted above. I send this out with the initial inquiry, ask the client to read it carefully and then call our toll free number to discuss particulars and ask questions. It also includes sample photographs showing a variety of portrait styles and locations and an overview of all the various portrait products we offer with specific prices for each variation. After reading over the information, the client has a better idea of questions she needs to ask. They are usually about product options or clothing choices. I answer questions as best I can over the phone, and then I tell them most product questions are easily answered when they come to the studio to view their portrait poses after the session because I have samples of every variation (i.e. canvas wall portraits, mat collections, miniature masterpiece canvas collections, etc.). As soon as people see samples of the choices, they get a strong gut feeling of what they like.

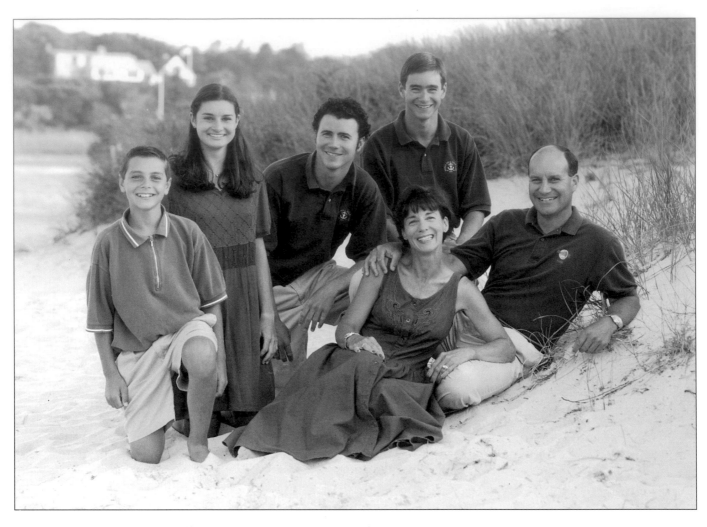

3-1: I work exclusively in black and white portraiture, and many clients initially assume it doesn't matter what colors you wear for a black and white photograph. It is important they realize it makes a big difference. I educate them on the difference between tones, and I ask them to wear either all dark, all medium, or all light. The dark clothing worn in this image creates a dramatic look against the light tone of the dunes. Photo by Helen T. Boursier.

Clothing

With the product questions mostly answered, we move on to clothing. Ask the client to describe the clothing she is thinking about having her family wear for the portrait. If she has not yet decided, ask her what she wants to wear and then help her make decisions from there. My goal with clothing is to make it almost neutral. I don't want clothing that is so trendy it will be out of style the next year, nor do I want it so "busy" that it detracts from the faces. Some clients choose to all wear the same thing because it is the easiest for them to coordinate.

For example, a family gathered for a surprise fortieth anniversary portrait. The children didn't tell their parents until it was literally time to throw on some clothes and go to the beach. To make the situation hassle-free, they opted for everyone to wear jeans and white t-shirts. It was easy for everyone, including the parents, and the end result keeps the focus on the faces and off of the clothing (see photo 1-2 on page 7).

Another family might choose to wear clothes from the same color family (i.e. all pastels, or all light neutrals, or all navy). The larger the group, the more important it is to keep the clothing as simple as possible. Clients also should choose clothes which reflect their lifestyles, their personal tastes, and their closets. I don't want a family to go to the

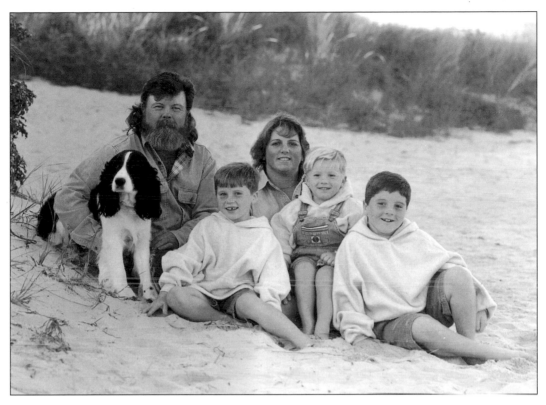

3-2: *Light toned clothing has a youthful feeling. Many of my clients prefer white clothing even for portraits created during fall. Photo by Helen T. Boursier.*

3-3: *Ultimately, you must photograph people in the clothing that most suits their style. A white shirt might have been better, but he preferred the stripes. Photo by Helen T. Boursier.*

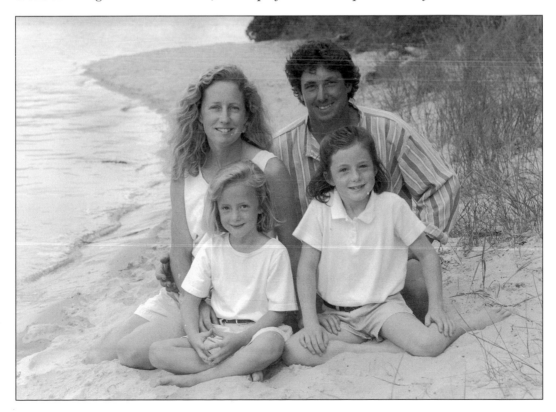

3-4: *Peter Straw prefers in person clothing consultations. He works with clients during the planning and sales sessions, and his wife, Marg does the photography. Here's a picture of their studio in New Zealand. Photo by Marg Straw.*

3-5: *Marg Straw prefers coordinated clothing which reflects the lifestyle of the clients. She said sometimes they understand what she is looking for (like this family), and sometimes not. Photo by Marg Straw.*

mall to buy an entire family wardrobe for their portrait session. What they have in their closet now is who they are, and that is what I want to photograph.

Marg and Peter Straw of Christchurch, New Zealand also do a combination phone and in-person consultation. They prefer in-person, but often must use only the telephone as their clients are scattered all over the South Island. Marg explained, "When they show up to the portrait session and the clothing is coordinated, it means they know what we are about and that they have the clothes. When they don't have the clothes, then we make the best of it. We try to keep the balance and come up with something that is acceptable."

When it doesn't "work," it is very obvious. Arlington, Texas photographer Roy Madearis said, "Clothing is probably the biggest problem we run into. Even though we encourage them to come into the studio, and we send off a set of sample wallets to those who can't come in, some times people just don't understand how important it is to blend the clothing amongst the subjects and in harmony with the setting. When they get it, they get it. When they don't, they look like they are going to fly over the entrance to Six Flags Over Texas!"

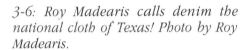

3-6: Roy Madearis calls denim the national cloth of Texas! Photo by Roy Madearis.

Jay Goldsmith prefers to conduct a planning session in his studio. He shows clients a slide program which covers a wide range of portrait styles. Then he begins asking questions. "I am looking to fulfill the family's need, so I always ask what is their first priority. I want to know how they visualize the portrait, and then my goal is to fulfill their vision," he explained. Getting the client to narrow down the location for the session is an easy starting point, and he says the clothing and design elements naturally follow.

To help him with the design elements, he asks if they want to be looking at the camera or interacting and doing something within the

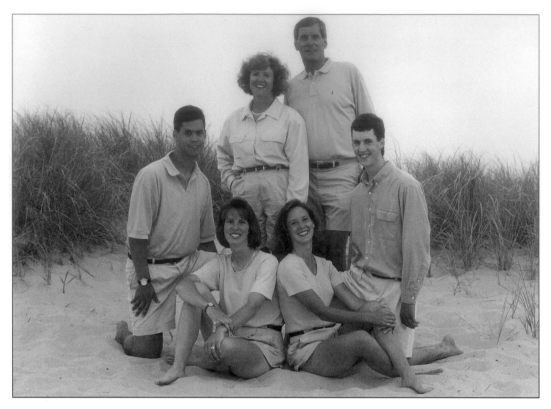

3-7: Photographer Ed Lilley likes his families to wear all the same pastel colored shirts. Photo by Ed Lilley.

3-8: Here's a studio family portrait without a clothing consultation prior to the session. Without a consultation, sometimes you have to make the best of it. Photo by Ed Lilley.

3-9: Almost all of Goldsmith's clients say they want something natural, something unposed, and something outdoors. Photo by Jay Goldsmith.

portrait. He also asks if they want the portrait to be horizontal or vertical and framed as an oval or a rectangle. "I always use hand motions to show what I mean by horizontal or vertical because I want to make sure they realize what I am asking. I think it is important to find out if they have thought about these design elements," Goldsmith explained, adding, "I don't worry about asking them to wear colors that will match their existing decor. The portrait is going to be around much longer than their current decor. Also, I like to think we are creating something that is much more important than just another piece of furniture."

CHAPTER FOUR

Portraits Require People Skills

Photographing family groups requires the same passion for the people as you have for photography itself. If you are not a "people person," you cannot be a successful family portrait photographer. People portraits require people skills.

Portrait Psychology

Macon, Georgia photographer Horace Holmes said the best preparation for becoming a family portrait photographer is a course in psychology at your local university. "The best rule of thumb in our industry is to treat everyone with respect, regardless of their age or their actions," Holmes explained, "In a very nice way, I let them know that I am in charge, but they think they are in charge!" He also said it is important not to pre-judge a situation. "On one hand you must know what you are going to do with a portrait session, and on the other hand you must be flexible," he noted.

Photographers have to "read" people and how to adapt to the needs of their subjects. When a child does not want to sit next to a sibling, be considerate enough to move them to a new spot. If an infant gets fussy and needs to nurse or a toddler gets extra fidgety and needs to take time to run up and down the beach, allow the extra time. "Patience is the key," Holmes said, "It is more than a virtue. If you don't have it, you're not going to be in business long ... especially when you're working with kids!"

Working with Different Ages

With a shy child, Holmes suggested the best tactic is to make sure to call the child by name. Also, look to see which parent that child gravitates towards and then always position the child by that parent. Meanwhile, he ignores the bossy or outspoken child. When he does talk to the bossy child, he said he uses what he calls his "Bill Cosby mode." "Have you ever seen Bill Cosby talk to kids on television? He

"Photographers have to... adapt to the needs of their subjects."

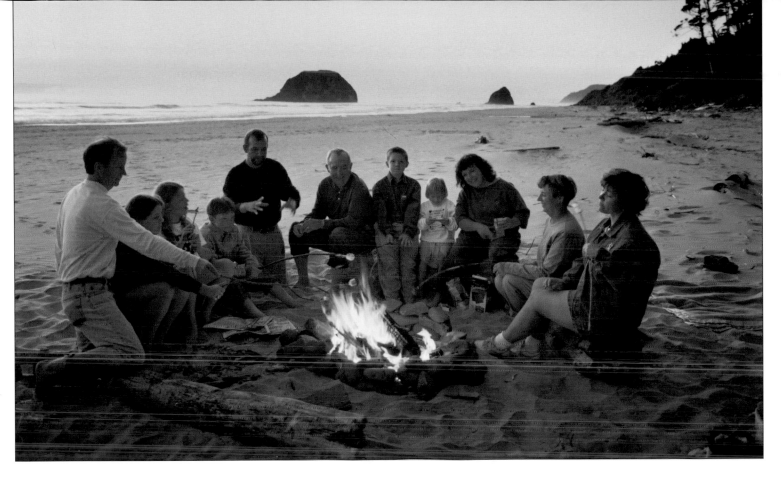

Above: Ken Whitmire designs one of a kind portraits which portray the family engaged in an activity that they enjoy doing together. Photo by Ken Whitmire.

Below: Whitmire tries to capture the lifestyle and atmosphere of his subjects. His client expects him to create an image worthy of wall decor. This image was 80x44 for the client with three 54x32 for their children. Photo by Ken Whitmire.

Above: The photographer uses the planning session to help the client design their portrait. He helps decide location, clothing and mood. Photo by Ken Whitmire.

Below: In this portrait, it's fairly obvious that the photographer had an opportunity to have a clothing consultation with the clients before they came in for their sitting. Photo by Ed Lilley.

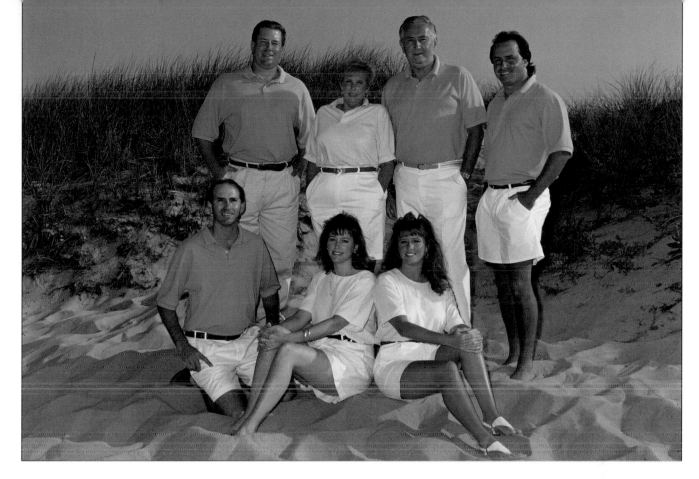

Above: This photographer likes to color coordinate his subjects. With a session on the beach, he prefers the subjects wear the same colored pastel shirt which creates a signature style for the subjects and the photographer. Photo by Ed Lilley.

Below: This Michigan photographer uses the traditional composition element and adds props to finish the storytelling look of the portrait. Photo by Dennis Craft.

A pram is a great prop for a family with a little one. The storytelling style is one of this photographer's favorite looks. Photo by Charla Holmes.

talks back to them the same way they talk to him. I might say something like, "Give me my ball back! Who's ball is it? Yours? No it is my ball? Who's studio is it? Do you see your name on the studio? It is my studio, that means it is my ball! Give me my ball back!' Mom and Dad are behind me laughing. Then they tell their child to give Mr. Holmes the ball back."

I meet most of my clients for the first time at the portrait location, and I make it a point to introduce myself to all of the family members. For little ones, I often get down on my hands and knees so I can greet them at eye level. Then I introduce myself as "Mrs. B." It is common for the mother to already refer to me by my first name, but I want the young children to think of me as "Mrs. B" and not "Helen." "Mrs. B" is someone who can and will take control of the situation, and "Helen" is someone more on the friend level. I will be friendly, but I need to be in control. "Mrs. B" is less formal than "Mrs. Boursier" and more teacher-like than just going by my first name.

When younger children do not want to be photographed, it is often because they are showing off for their parents. The first thing to do is reassure the mother not to worry. If she does not get stressed out over her child's behavior, the bad behavior will often go away.

4-1: The larger the group, the more personality variables you must work with. When there are a lot of little ones, I tell all the adults that if they will keep looking at the camera (and not sneak a peak at the child in their lap) I guarantee I will get the children's attention. Photo by Helen T. Boursier.

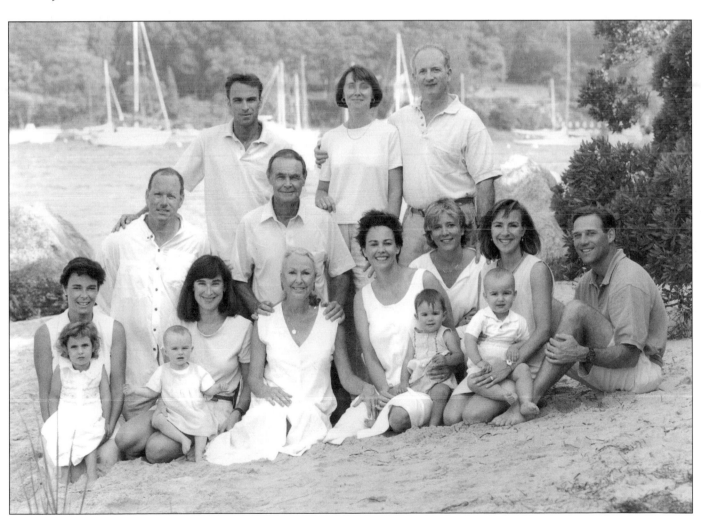

4-2: Horace Holmes uses what his calls his "Bill Cosby" mode when he is working with young children. Photo by Horace Holmes.

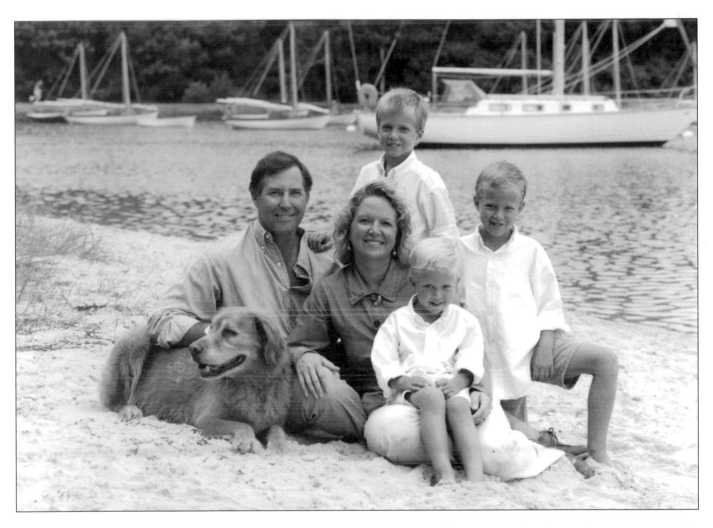

4-3: *When it comes to portrait photography, dogs are people too. I position the dog nearest the person who can exercise the most control. Then, just like with an infant or two-year-old, I ask everyone to ignore the dog and let me do my thing. Photo by Helen T. Boursier.*

The next step is to distract the child by doing a fun activity. I might challenge the kids to a race down the beach, or I maybe set up a "contest" to see who can throw a rock the farthest.

Once the children are involved in an activity, it is easier to side-step back to photographing. I will take some "candid" images while they are looking for seashells or throwing rocks, and then I will try again to do a few quick formal poses.

When I am greeting teenagers, I take a more laid-back, "Hey things are pretty cool" attitude. I understand that they generally do not want to be there and that the whole family portrait concept is most uncool, so I just bring their feelings right out in the open. I might say something like, "Isn't this the stupidest thing you've had to do in this lifetime?! Of course, it could be worse ... all your friends at school could be here watching!"

Teenage boys often come to the session with a bad attitude. First of all, they hate what they are wearing. Then, to go out in public with their family while they are dressed like a dork is the ultimate embarrassment. Their feelings are very real, so you can't ignore them.

I have spent a lot of time with groups of teenagers as youth group leader at my church, including week-long camping trips amid 100,000

4-4: *This mother opted to let her boys be boys. Instead of getting stressed out about the clothing or hats they wore, she decided the portrait should capture her boys just as they wanted to be captured, hats and all. Photo by Helen T. Boursier.*

•**Teenagers can be a difficult age group to deal with. Telling the teenagers up front that you *know* they don't want to be there helps to break the ice.**

other teenagers. The tactic that works the best for me is to let my outspoken nature rise to the occasion. I badger, cajole, tease, and do anything I can think of to get the teenager to lighten up! If they are wearing something the parent doesn't like, usually ugly sneakers or a ball cap, I tell the parents to leave the problem to me. If a parent insists they take off the offending item, the teenager will be in a bad mood for the duration of the session (and maybe the duration of the day or week or month!). When an outsider does the insisting, the teenager is stunned.

For example, when I know the mother wants all the children to be barefoot at the beach, I will tell everyone to take their shoes off so we can get started. If a teenager objects, I will walk over to them, put my hands on my hips, and say, "We're not moving until you take your shoes off! I've got plenty of time to be here all night, or you can whip off your shoes and we can be out of here in fifteen minutes. Your choice!" They want to get it over with quickly, so they take their shoes off.

My action also establishes early on that I mean business. Then, if a teenager is wearing a ball cap and mom wants it off, I just walk right over to the child, take the hat off his head, and say, "No hats on in my photographs!"

They are not allowed to wear hats inside the school building, so they figure this is one more time when a teacher-type is telling them to take off their hats. They don't like it, but they resign themselves to my authority.

Occasionally, one will question why I want his hat or shoes off. Then I back up and very carefully explain. I still get my way, it just takes a minute or two longer.

Meanwhile, mom is in the background thinking, "YES! She did it!" (When it is my turn to have our family portrait created, I expect the photographer to use the same assertive authority with our teenager so I don't have to do it!)

Woonsocket, Rhode Island photographer Bob DiCaprio said when he has a tough teenager who doesn't want to be there, he works a lot harder to win them over.

DiCaprio said he often pulls aside the reluctant subject and says, "You have got to humor mom. It will be a lot easier for everyone. I know you don't want to be here, but just do it to make mom happy."

Then this father of two teenagers goes to the parents and asks them to leave the kids alone and let him take care of any attitude problem. "I tell them not to be a parent. If they are a parent it is much harder for me to do my job."

4-5: Calm reasoning helps this photographer win his subjects over. He gets the kids to "do this for mom" and then he gets the parents to leave the kids alone! Photo by Bob DiCaprio.

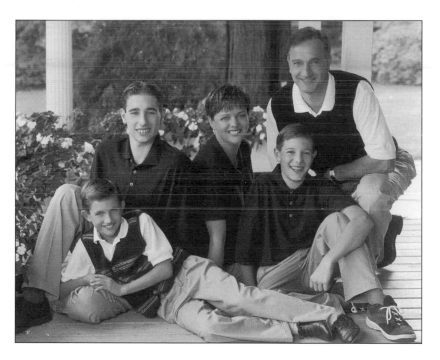

DiCaprio has the basic philosophy that the family portrait experience should be *fun!* He said, "We're not just selling an image. We're selling an experience. Before the mother even gets to the session she has gone through a lot of effort in juggling everyone's schedules, the timing of the day itself, coordinating the clothing and cajoling all the people. She may be mentally worn out by the time she gets to the session. We need to make the session fun, and make the whole experience pleasing."

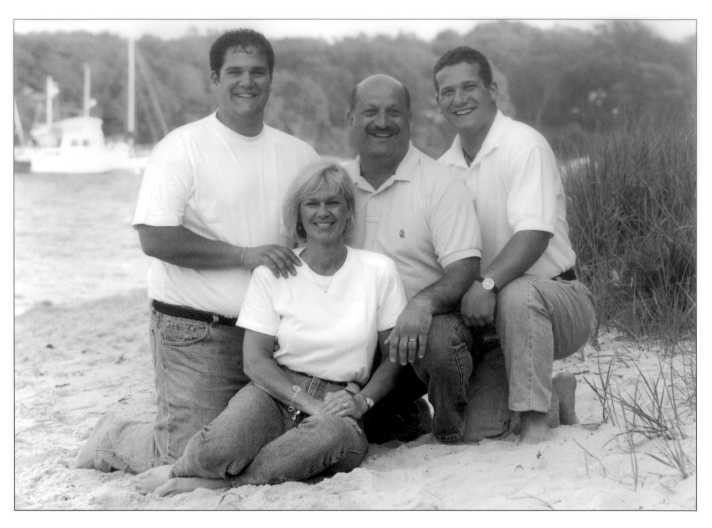

4-6: *Once the preliminary greetings and organizing are out of the way, I slip out of my director personality and into my entertainer mode to get the fun expressions my clients are expecting. Photo by Helen T. Boursier.*

I use the same "bossy-nice" approach for grandparents who don't want to be included in the photograph. Older people don't want to be remembered as old, which means they don't want to be photographed. They will often agree to be in the big group, but they DO NOT want to be photographed separately or with the smaller groups.

I told one mother I guaranteed I could get the grandmother to be in several other portrait groupings, but she just looked at me like I was out of my mind. She said her mother would never go for it! Easy. I just walked over to the grandmother and escorted her to where I wanted her to stand for the portrait. Of course she was too polite to object to me, a stranger, so we created some wonderful images that the family will always cherish!

Using Your Personality to Get the Right Shot

Like most photographers, during the actual session I take on an entirely different personality from the day to day Helen you might run into in the real world.

In fact, after two or three minutes of photographing, it is not uncommon for someone I know from church or socially whom I'm photographing for the first time to comment, "This is not the Helen Boursier

we know!" Basically, I am willing to do whatever it takes to gain the cooperation and the animated attention of my subjects. My camera act is a combination of my natural ability to take charge with my acquired skills of loud, silly, zany actions and commentary.

My objective is for my subjects to forget they are being photographed and just allow themselves to have fun. I've actually had strangers come up to me at my favorite photography locations and book a sitting based entirely upon watching how I work with people. The key to getting people to loosen up is to lighten up yourself! You can't take yourself, or the situation, too seriously.

Jay Goldsmith also looks for the personality of the family itself. He said he doesn't pose people in terms of composition. Instead, he will just ask for them to sit or stand in a particular spot, and then he observes.

"Generally, you will automatically see who is close to whom. You will see their personalities unfold," he said, adding that he will then go in and refine things.

"The more things I change from their original pose, the worse things tend to get. I might even get to a point where I tell them to just start again. I want them to do their own poses so it relates to them and to their personalities," he said.

"My objective is for my clients to forget they are being photographed..."

4-7: Jay Goldsmith prefers to leave the family alone and let them pose themselves. He says the personality of the group will unfold naturally when an outsider doesn't get in the way. Photo by Jay Goldsmith.

"...successful photographers bring a distinct sense of style to their work."

Chapter Five

A Matter of Style

A few photographers are eclectic, doing a little bit of a lot of different looks. However, most successful photographers bring a distinct sense of style to their work. Style is not something photographers automatically have the first time they pick up a camera. It takes a lot of dabbling in a variety of looks until you settle on one or two that just seem to "fit" your tastes. Since like attracts like, clients gravitate toward the photographer whose images also suit their style.

Creating Your Style

During my beginning years as a photographer, I photographed anything and everything that came my way. I also attended every photography seminar possible, then promptly went out and tried to duplicate what the instructor had taught.

Over time, I gradually discarded what really wasn't me, and did more and more of what I loved. I went from being a generalist to a specialist. Where once my Yellow Pages ad read "weddings, seniors, families, passports, children, mother-child, business portraits, commercial," now it reads, "working exclusively with hand colored black and white portraits of families and children."

The two styles I ultimately settled upon include the "casually perfect candid" where the subjects are interacting amongst themselves and the more traditional posed group with everyone looking at the camera. My portrait look is distinct even within those two styles. In the posed groups, I like to get people as close together as possible with lots of touching. I also aim to get people to laugh so their real sparkle shines through. I want the viewer to think that, even though they may not personally know the subjects, the expressions make them feel like they do know them! I fill the frame of the camera with the people, with only a small amount of background. With this style, my objective is to show the family, with the setting playing only a secondary role.

The opposite holds true with my pictorial images. I show the subjects in about one-third of the overall image size, and the scenery takes the rest of the space. I don't want the people to look at the camera, and the

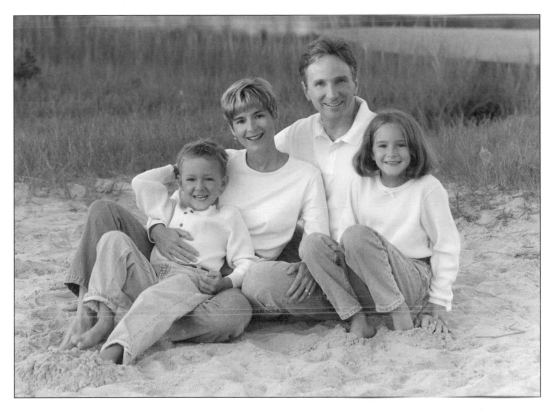

5-1: Close groupings, animated expressions and relaxed posing are important elements in my own camera portrait style. Photo by Helen T. Boursier.

5-2: When a client says they want a "candid" portrait style, they are looking for an image that shows their family doing something believable. Photo by Helen T. Boursier.

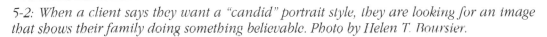

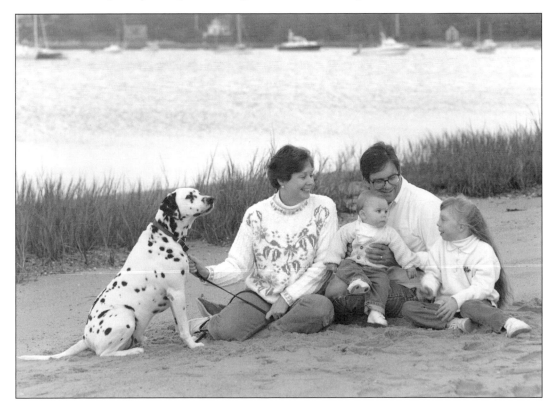

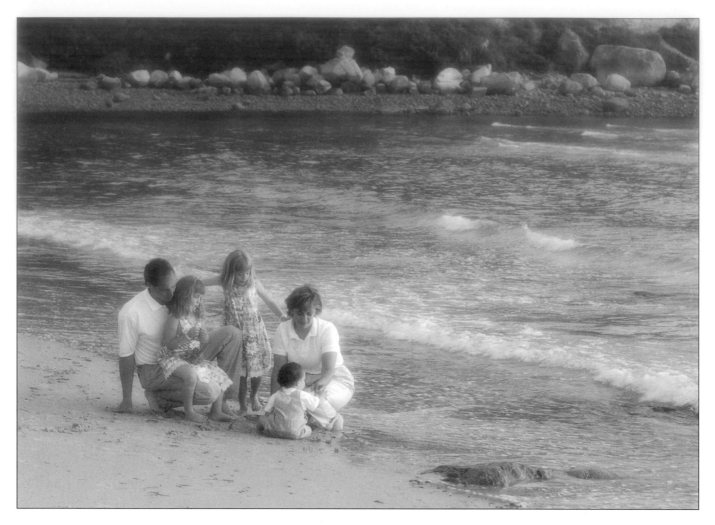

5-3: It is much more difficult to pose the "candid" style image. Without the photographer interfering or interacting, the posing and grouping must look natural and relaxed while also showing off the subjects to their best advantage. Photo by Helen T. Boursier.

objective is to create a feeling that the viewer is almost looking through a window and catching a glimpse of a very personal family moment. The setting is very important because it takes up such a large percentage of the space. I pay attention to composition, line and design, but I also take care to include elements which will remind the family of why that setting is so important in their lives.

A Variety of Styles

Marshall, Michigan photographer Dennis Craft also does both an interacting and what he calls "casual comfortable" styles. "I want to make it look like they were doing whatever they were doing and I just happened to come by with my camera, took an image, then took off so they didn't even know I was there," he said. He asks them what kinds of hobbies or activities they have that they do together. That then becomes the theme of the portrait. If they don't have anything they all do together, then he helps them choose something, like a picnic or a walk along the beach.

With Craft's casual comfortable style, he does not always try to keep them close together. Instead, he prefers to see a little space between the subjects. He said he does use traditional composition elements like

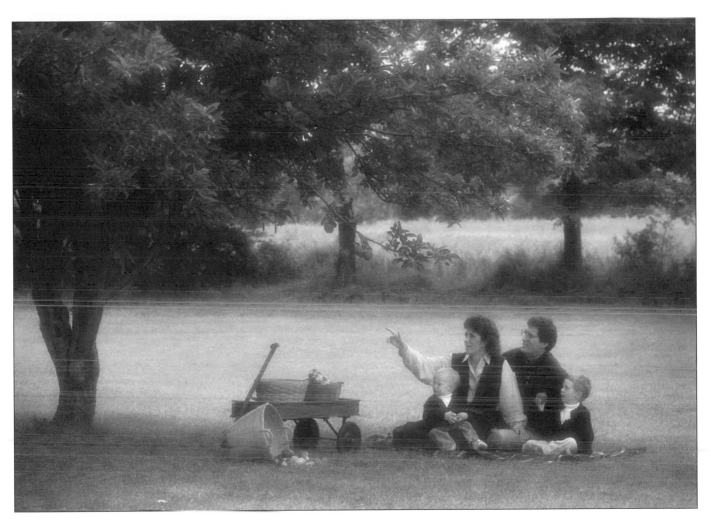

5-4: *The photographer carefully positions his subjects within the environment and adds props to finish the storytelling look. Photo by Dennis Craft.*

a pyramid or a triangle to make the look flow, but he doesn't want people on top of each other. He explained, "I do want them touching a little. Maybe the hands on shoulders, holding hands, or putting arms around each other. My ultimate goal is to make them look comfortable together. If they look uncomfortable touching, I'll take the hand back off the person's shoulder and maybe have dad put it in his pocket. I want the look comfortable, so I don't want them doing something that they don't want to do."

Arlington, Texas photographer Roy Madearis said his main objective with a family portrait is to have them dress casual or "corporate casual." He doesn't want to do an outdoor family portrait with anyone wearing a suit and tie. He also encourages everyone in the family to wear oxford button down long sleeved shirts or denim, "the national cloth of Texas." His outdoor family groups are always full length, and he aims to build a pyramid look.

Ed Lilley's signature look is his beach portraits of families dressed in matching clothing. Pastel golf shirts are the most popular clothing choices for his clients. "My clients want a lifestyle portrait at their home, on the beach or maybe at the golf course. If it is a crummy weather night and I ask if they want to go to the studio instead, they always say

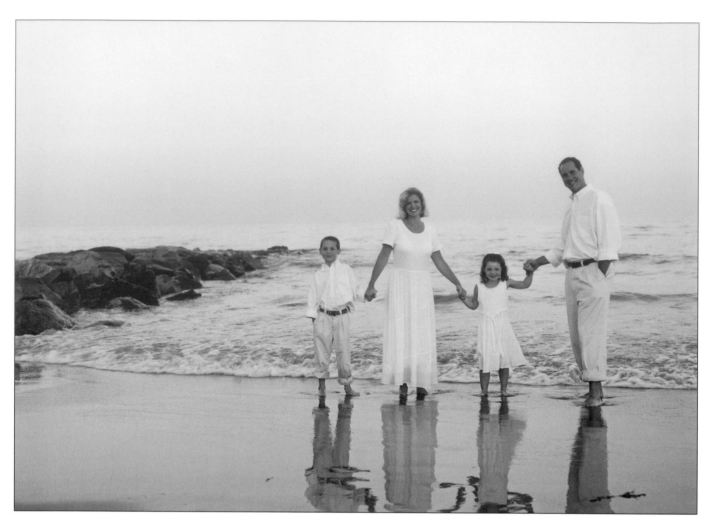

5-5: *Goldsmith looks for simple and uncluttered backgrounds. When he's photographing at the beach, he will work hard to find a place without seaweed. He also will have his barefoot clients walk into the water a little bit to get to the location for the portrait so there are no footprints marking the sand around them. He wants very simple areas in the foreground as well as the background. When working with color film, he also want to keep in chromatically simple as well. Photo by Jay Goldsmith.*

absolutely not! To them, the studio portrait is a record photograph and the last thing they would want."

Jay Goldsmith avoids placing subjects in positions based upon age and rank (i.e. the oldest stands, the youngest sits). "I don't necessarily put the father at the top, back in the dominant or strongest position. In a seated pose, I don't put the father at the top unless there is a good reason to do so. The family members will get into their own political relationship units naturally if I stay out of the way." He wants to photograph the relationships as they are, saying it would be wrong for him to change things.

Marg Straw likes both formally posed portraits and the more relaxed, interactive style. She prefers to photograph only during the last two hours of the day when the light is soft, and she frequently uses a soft focus filter to cut back on any unwanted contrast.

Her husband, Peter does most of the planning consultations, either on the phone or in person. He helps the clients select appropriate clothing for the location and to suit their own style. Because the Straws have so many portraits on display (in homes and at public locations), new clients mimic the look they see. The end result is what Marg calls "relaxed formal."

5-6: *When we were on a lecture tour tn New Zealand, Marg Straw photographed us at her daughter's sheep station on the South Island. This "faces forward" represents her more traditional style. Photo by Marg Straw.*

5-7 (right): My all-time favorite portrait of our family captures the relationship of the people within our small family — two adults devoted to their son who is looking out at the viewer (and the world) with all the energy and anticipation and optimism that comes with being a young adult. The portrait hangs above our fireplace as a memento to the wonderful trip "down under" and to the slice of life representing our son's high school years. Photo by Marg Straw.

5-8 (below): "Relaxed formal" describes New Zealand photographers Marg and Peter Straw's family portrait style. Photo by Marg Straw.

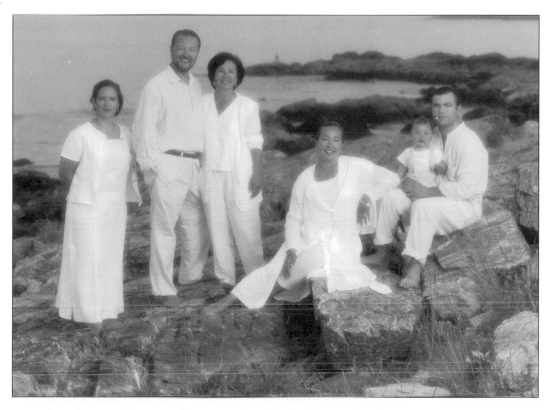

5 9: *This photographer's goal is a non-descript background where there are no minor elements that could distract the eye. Photo by Mark Spencer.*

5-10: *Spencer makes sure he takes time to look for little things in the viewfinder that would detract from the image. Photo by Mark Spencer.*

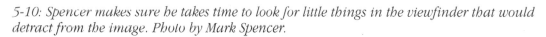

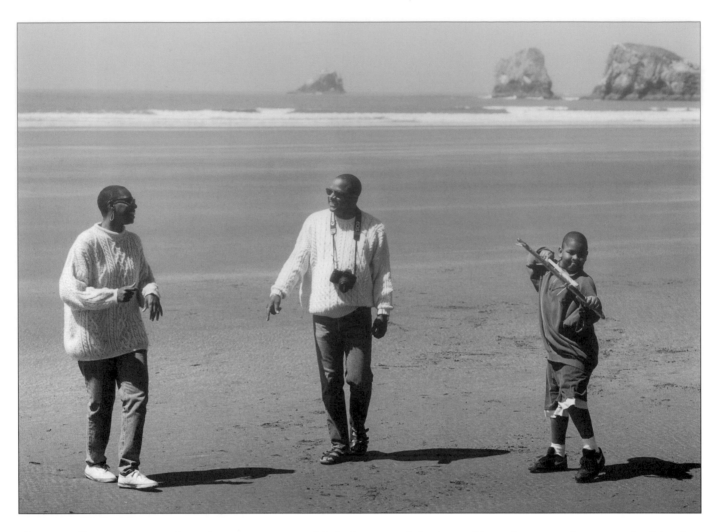

5-11: Wall portraits are the primary objective for this Yakima, Washington photographer. He designs a theme with the client ahead of time, and the works to create a relaxed image that shows the relationship of the subjects. Photo by Ken Whitmire.

Mark Spencer of Andover, Massachusetts strives to make his photographs look like paintings in the traditional art sense of the word. He chooses his light, composition and background much like a painter would have chosen. Spencer makes sure there are no distractions in the background. He also uses selective focus to insure the background goes softly out of focus so it does not overwhelm the subjects.

Ken Whitmire is known for creating portraits that will hang as wall decor in his clients' homes. He tries to capture the feeling, atmosphere and lifestyle of his subjects. Whitmire said capturing their lifestyle is an absolute necessity if he expects to decorate his clients' homes with his images. He said a group of people lined up with a plain background shows what everyone looks like, but it has little appeal as a piece of artwork to hang on the wall.

Randy Taylor spends a lot of his session time on setting up. When in the family's home, he includes personal items that are special to the subjects. These personal items, such as pieces of art, add to the portrait and give a sense of individuality and uniqueness to each portrait. The portrait will also hold much more meaning for the family.

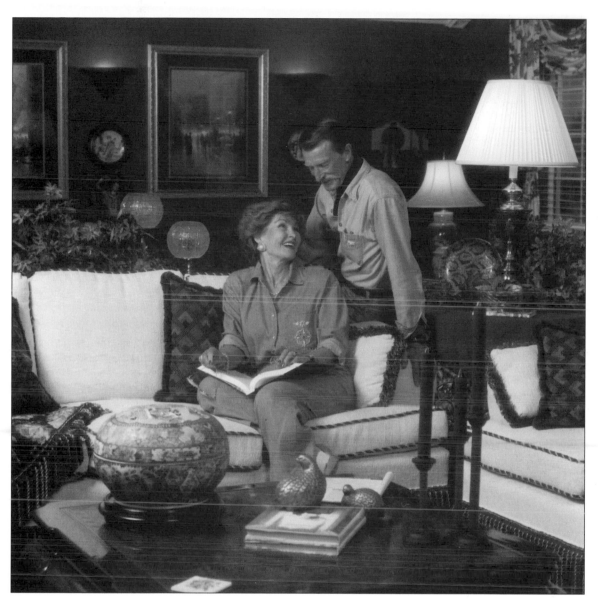

5-12: *Taking time to meticulously arrange the foreground is an important part of Taylor's set up time. He includes pieces of art that reflect the subjects' taste and style. Photo by Randy Taylor.*

"There are a few basic components that you must have..."

Chapter Six

Packing Your Camera Bag

Packing your camera bag is as personal as decorating your living room or selecting patterns for a china, crystal and silver bridal registry. There are a few basic components that you must have, but exactly what those components are is completely subjective.

Camera Selection

Camera selection format could be a "small format" 35mm, a "medium format" that takes 120 or 220 film, or a "large format" view camera. New photographers generally start with a 35mm because it is both familiar and affordable. Its small size makes it easy to pack, easy to handle, and easy to add on all the extra lenses and accessories. Small is also its biggest drawback. The negative size limits quality portrait enlargements to 11x14.

On the opposite spectrum, large format cameras produce exceptional quality enlargements in virtually any wall portrait size. The large size also makes the camera heavy and cumbersome to pack and carry, awkward to use. Film is also considerably more expensive. Photographers who swear by a view camera generally limit its use to studio portraits, commercial work and personal landscape photography.

The medium format camera tucks itself nicely in between. Where the square format cameras like the Hasselblad, Yashicamat, and Bronica SQ are the preferred camera for wedding photographers, the rectangular format camera tops the full-time portrait photographer wish list. Mamiya RB67, called the "RB," was the most recommended camera of choice for the contributing photographers.

The 6x7cm negative is the largest "medium format," which brings it as close to the view camera as possible while still giving photographers portability and flexibility. The rectangular format enables photographers to create compositions within the viewfinder which are proportionally suitable for any standard size photographic paper (i.e. 16x20, 20x24, 24x30), compared to the square format negatives which require nearly one-third of the negative to be cropped off to proportion up to normal size prints. The RB's larger "medium" size makes it necessary to use a

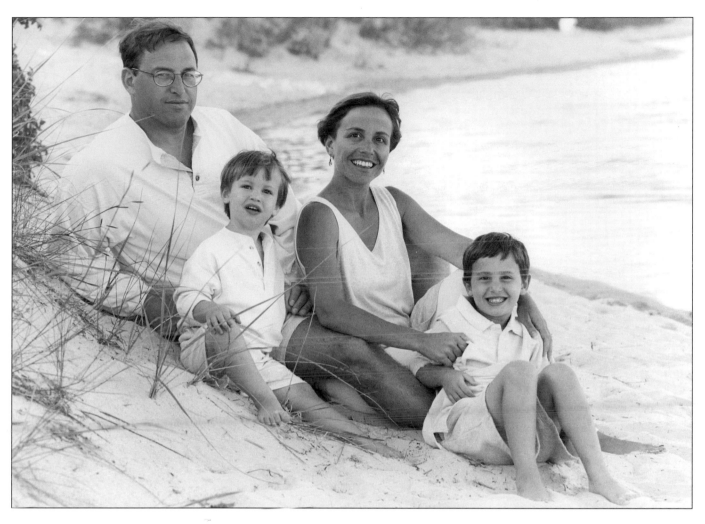

6-1: The less complicated your camera gear, the more available you are to focus your attention on your subjects and on composition, line and design. Photo by Helen T. Boursier.

tripod for sharpness. You can, however, get by without a tripod for the smaller format "medium" cameras.

The second most important item to pack in your camera bag is a back-up camera. Never leave home without it! If you rely on artificial lighting like a flash or strobe unit, make sure you also pack a back-up unit. I learned my lesson on the back-up camera the hard way. I went to a beach an hour away to photograph three small children. My faithful RB that had never given me a day of trouble wouldn't work. With the little children all dressed perfectly and the mother almost in tears, I had to call off the session.

Meanwhile, I got on the cell phone and had my husband literally drop what he was doing and race out with another camera. He arrived just as my next client was pulling into the parking lot. Later, I discovered that a tiny piece of sand had jammed in the leaf shutter. Now, a complete backup system stays in the trunk of my car from the day we open the studio in the spring until I do my last location session in the fall.

Equipment List

The rest of what you put in your camera bag is just as subjective as your camera choice. The three popular lenses to have handy include a

•For photographers who use flash on location, make sure to bring a backup and extra batteries.

wide angle, a "normal" and a long or telephoto. Most photographers rely upon a cable release to cut back on motion when they actually push the shutter and take the photograph. The equipment list also includes extra film backs, light meter with backup battery, tripod, lens shade, filters, plus plenty of film. For those using auxiliary light, bring your primary flash or strobe, a backup as well as extra batteries. In the trunk of my car I always keep an extra reflector, dark green plastic bags for subjects to sit on and keep their clothes from getting grass stains, insect repellent for summer bugs and a sealed container with an assortment of treats (bribes, rewards) for the kids.

My equipment list is shorter than what most photographers bring on location. A Chicago commercial photographer once said, "If I could photograph without a camera, I would!" I feel exactly the same way. I prefer to spend my time fiddling with the people, and not fiddling with the equipment. My list includes:

- A camera bag that I leave in the trunk of the car.

- RB67 with a 180mm lens (127mm for large groups/65mm for assignments in a home) with a Brightscreen to literally brighten the viewfinder for more accurate focusing

- Benbo tripod

- Two 220 film backs (one on the camera/one loaded for the next job)

- Minolta IV light meter

- Extra batteries for the light meter

- 18" cable release

- Complete back-up camera in a separate camera bag

- Kodak Tri-X Professional B&W film

- Kodak PMZ 1000 ASA color film for my occasional color session

New Zealand photographer Marg Straw's equipment list is typical of what most portrait photographers bring on location:

- Mamiya RZ with metered prism

- Lenses: 90mm, 180mm, 250mm

- Two 220 film backs for faster shooting and less film changing (less disruptive)

- Mamiya remote — "I can't stand being attached to the camera, and my best responses with the kids are when I move around a lot."

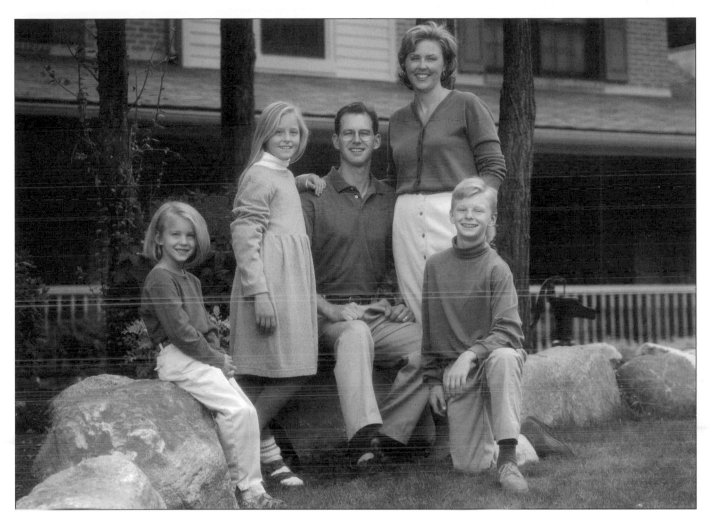

6-2: *Longer lenses like the 180mm on the RB are generally the preferred lens for most family portrait photographers. However, the "normal" lens (i.e. 127mm on the RB) works better when photographing larger groups because it enables the photographer to still work close enough to the subjects to still be able to communicate. Photo by Dennis Craft.*

- Mamiya lens shade with a homemade (black silk stocking) filter

- Cable release

- Mamiya case and a set of wheels

- Gitzo Tripod

- Kodak 400 VPH or GPY (rated at 320 ASA)

- Kodak 1000 GPZ (rated at 800 ASA) for extremely low light

When I am meeting a client on location, I load my camera with film and place it on the tripod, tuck a few extra rolls in my pocket, loop the light meter around my neck, count out the appropriate number of treats to give the children after the session, check to make sure I have my car keys in hand, then close the trunk and wait for my clients to arrive.

Ken Whitmire said photographers have been wrapped up talking about cameras and lenses and chemicals. He said, "Most painters didn't

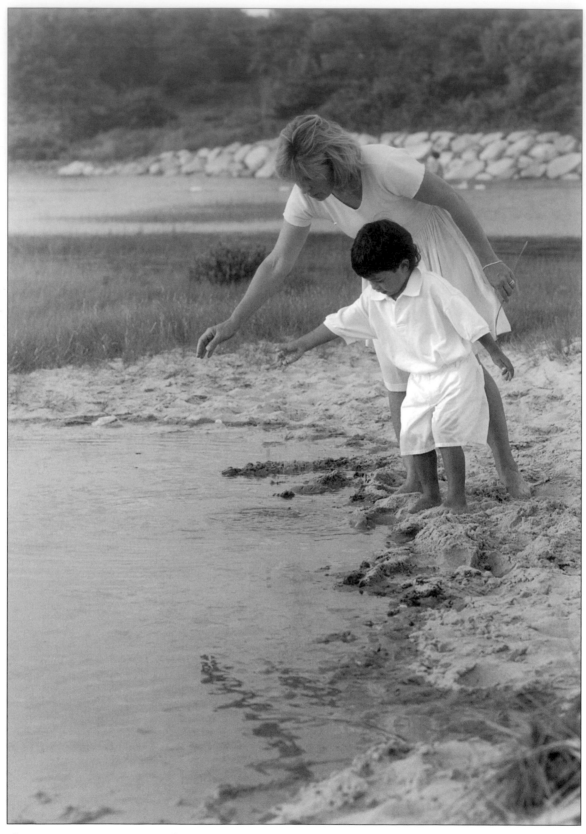

6-3: *Because I am unencumbered with equipment, I can easily move around, following the lead of what my client is doing. I am much less stressed, and the portraits are much more natural. Photo by Helen T. Boursier.*

6-4: Very soft late day light is the main light for this image. A Metz 45CT flash unit pops in a little bit of fill light. No diffusion filter. Photo by Marg Straw.

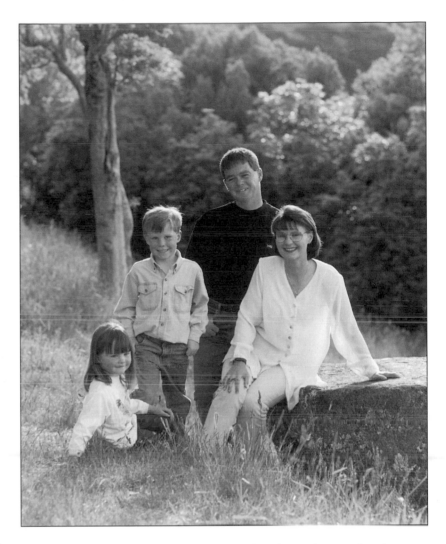

make their own paints from pigments. They knew how to lay them on the canvas to create beautiful masterpieces, but they didn't mix their paints or weave their own canvases. The important issue was not what kind of paint or what kind of brush or what kind of canvas, but how the painter used those tools to create a wonderful piece of art. Until recently, photographers have been caught up talking about the mechanics of our profession, and the aesthetic part has eluded us. We were craftsmen who made something. Now, we are finally turning our attention to creating the images themselves."

"Clients often recognize a photographer's style just by how he or she uses props."

Chapter Seven

Props

Using props within the photographic image is another area where photographers have very strong, and often opposite, viewpoints. Where one photographer uses props as little as possible, another may make the props an integral part of the design. One might use only props already available at the location, and another might bring them in by the truckloads. How you do or don't use props is part of your photographic signature. Clients often recognize a photographer's style just by how he or she uses props.

When I must use something other then people, I prefer to use props readily available within the location, whether it is a front porch, a tree, the side of a hill or sand dune, a beach jetty, or even a single rock or park bench. Since these elements are already part of the landscape, they are natural for people to sit or stand on, or to lean against.

For the more mobile two and three-year-olds, I lift them to the same low, flat, rock, but I position them standing. Since they are not used to standing on a rock it actually fascinates them for a few seconds — just long enough to take a few photographs!

As a back-up plan for crowd control, I keep a white whicker settee in the trunk of my car. It will seat two infants, or two to three toddlers. I use this piece when I have a lot of young cousins to photograph as part of a family reunion type session.

First, I have the children who are old enough to stay put stand behind the settee. If I'm not sure they will, in fact, stay still, I take one of their little hands and place it on the settee, and say, "Now hold on tight!" Then I add the little ones, propping them on the bench against the white pillows. All of this posing takes place in a few split seconds, and it is a wild event to watch. All the parents are running in and out, putting their wayward child back in place. We are all screaming and making all kinds of funny noises and faces. The prop enables me to photograph a one-of-a-kind image of kids that otherwise would never sit still long enough to take even 1/500th of a second exposure.

When she gets the chance, Corsicana, Texas photographer Charla Holmes loves using props. She has angel wings and white dresses,

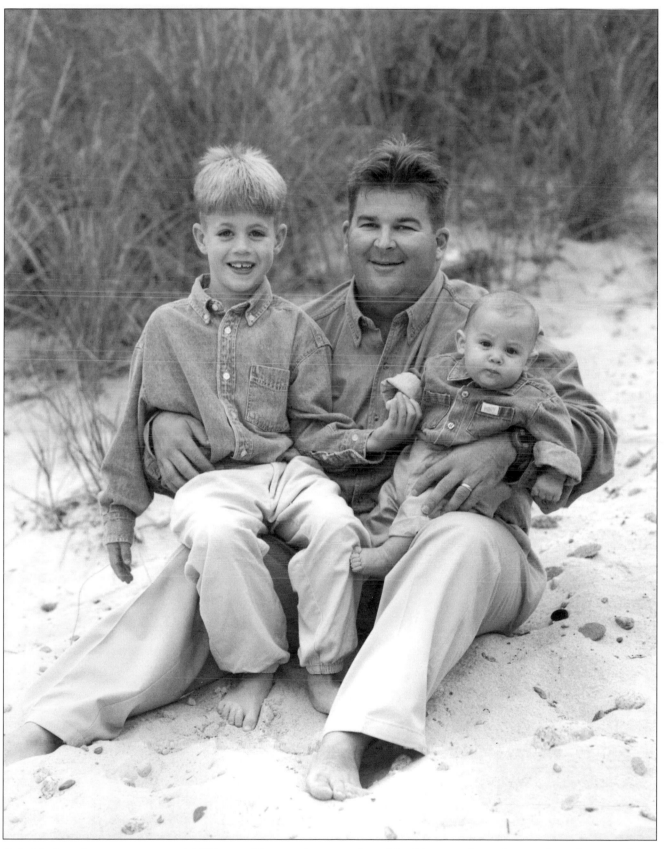

7-1: *My favorite props are people! I like working on the ground, and building up from there. When photographing children, I love the "pigpile" look where all the kids are piled around the parents. Photo by Helen T. Boursier.*

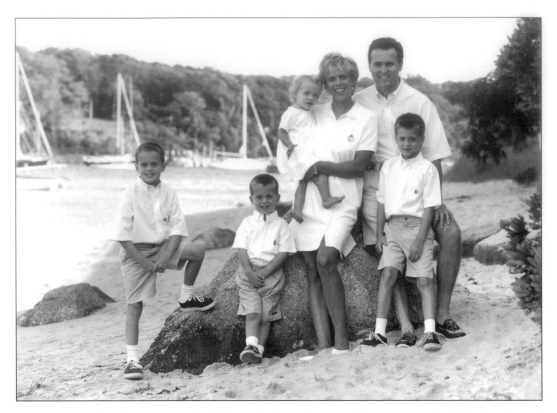

7-2: Posing a family against a boulder at the beach gives subjects gives a kick-back, relaxed feeling to the portrait. Photo by Helen T. Boursier.

7-3: I use larger natural elements. When I lift a child up on a rock, they stay put long enough for me to position the others and take a few images. Photo by Helen T. Boursier.

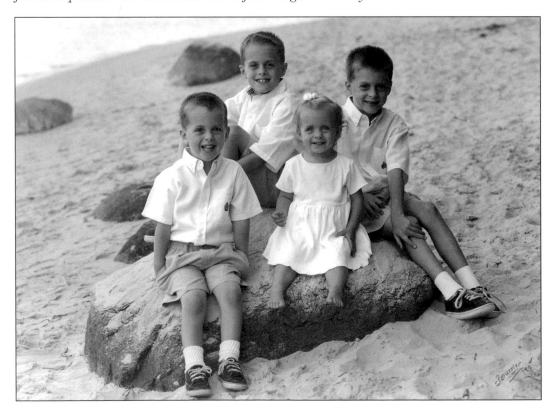

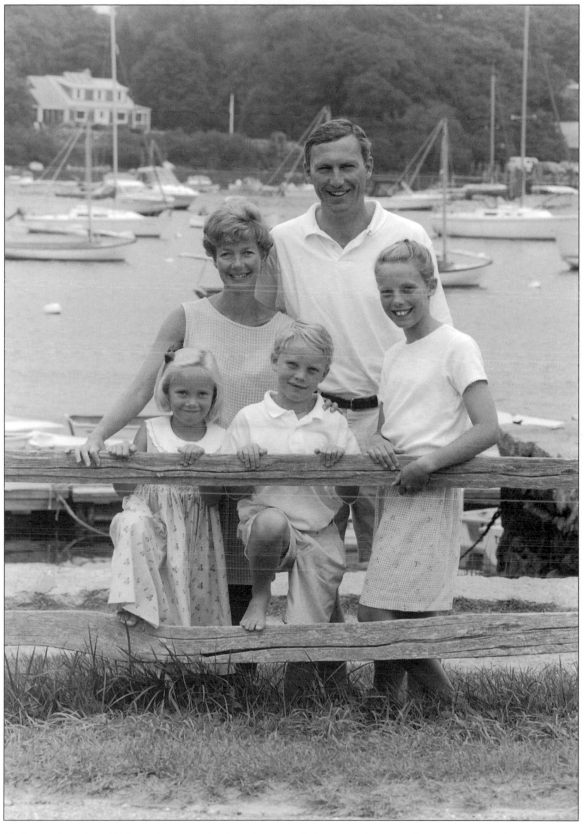

7-4: *Getting the children involved in the photograph is easy when you have them climb up or lean against a fence. Photo by Helen T. Boursier.*

7-5 (right): This small town based photographer often travels as far as two hundred miles to do a day or two of photography at the home of a preferred client. She makes use of every prop on the property! Photo by Charla Holmes.

7-6 (below): With older families, Charla Holmes uses very little props. She will either bring a blanket for them to sit on and build a pyramid up from there, or she might use her wrought iron bench and have someone sit on the arms. Photo by Charla Holmes.

whicker baskets, an antique English pram, whicker strollers in an assortment of colors, books, bushel baskets to fill with apples and a wrought iron bench. "I love the real whimsical images of two kids holding hands walking away from the camera, or young children in white dresses wearing angel wings and having a picnic, but you can only do the storytelling images with children maybe six or seven and younger. When the kids are older than that, the moms and dads want to see their faces," she said, adding that there is no point in doing the storytelling style with older children because the parents just won't buy them.

Andover, Massachusetts photographer Mark Spencer has one strong principal on how he uses props: use them discreetly. He said small props must be used only as a symbol because they mean something to the subjects. For example, a special blanket for a baby or a treasured stuffed animal for a toddler. For larger props used to pose groups of people, he relies upon elegant furniture that his clients would use in their own homes. The props must also match the mood of the portrait and the personality of the subject. For example, he will use a desk only in an image of a studious person, and a delicate lady's chair might be his choice for a portrait of a little girl wearing a white dress.

When he uses props to help position larger groups or people, his goal is to show those props as little as possible. "I don't like props that are meant for photographers. If you wouldn't put the prop in your home, why would you want to put it in a portrait?" Spencer asked.

Arlington, Texas photographer Roy Madearis built a custom "prop" to enable him to turn a dead space at the rear of his studio into a convenient place to do "location" photography. He built a fake wall ten inches from the outside wall of his studio and overlaid it with slat boards so it would look like an old Victorian porch. He added a door, gingerbread trim, porch railing, swing, and steps for a versatile prop. The porch faces south, so he uses the last light of the day for beautiful three-quarter

•**Props should match the mood of the portrait and the personality of the subjects.**

7-7: Before the porch "prop" was added to the back of Madearis Studio. Photo by Roy Madearis.

7-8: Initial framing of the porch. Photo by Roy Madearis.

7-9: The back wall and fake door are installed. Photo by Roy Madearis.

lighting that he said is "just gorgeous." During the spring and summer months, he does one or two sessions there daily. Using all natural light and Kodak PPF 400 film (rated at 400ASA), he does two or three groupings of the entire family with the porch as the prop and background.

To give each session variety, he then does the smaller groups (i.e. couples, children, individuals) in the various custom landscaped settings around the porch.

For example, the seven-foot-high arbor with a black gate won't work for larger family groups, but it is perfect for the smaller groups within

7-10: Gingerbread trim, porch swing, and landscaping complete the look. Photo by Roy Madearis.

7-11: Porch prop in action! Photo by Roy Madearis.

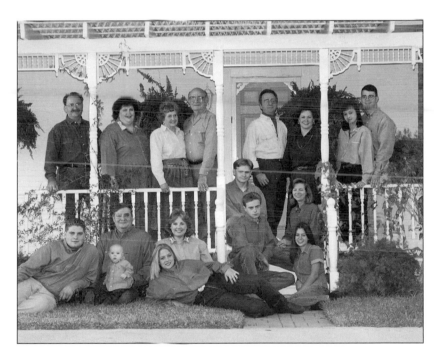

the family. He planted pampas grass (similar to beach grass but a lot bushier) to cover the background and hide as much of the studio building as possible. He said, "My goal is to subdue all the architectural elements so the focus is on the subjects."

CHAPTER EIGHT

Studio Posing & Lighting Techniques

There are so many types of products on the market for lighting studio portraits that it can be overwhelming. In spite of this great variety of actual equipment, the common denominators amongst most professional photographers include a main light, a fill light, a background or separation light, and an overhead or hair light. Some photographers bounce the main light into an umbrella while others aim it through a softbox. For fill light, some use what they call "fixed fill," a bank of lights permanently set so the output is about one to one-and-one-half stops less than the main light. Others duplicate their main light source, but set the output at a lower level. When one photographer likes the overhead or hair light to be noticeable, another prefers the light to do no more then separate the hair of the subjects from the background. Some photographers like to light the background so it is noticeable, where others don't use a background light at all.

In spite of the variations with the lighting style, photographers agree that the one important fact is to learn the capabilities and the limitations of your camera room and your lighting equipment. Consistency is the key.

Roy Madearis works in an "L" shaped camera room. It is 14'x22', and he said the minimal ideal would be 16'x25'. His main objective with his lighting is to achieve an $f8$ exposure off the faces, and he uses what he calls "directional, but soft" lighting. He uses a Photogenic StudioMaster II main light set for an $f8$ exposure, and he uses a bank of Norman 800 watt second lights bouncing off the rear wall of the camera room as fill light. He doesn't use a background light, but he does use a separation light that is bolted to the wall near the low key (dark) end of his camera room. He uses his high key (light) side with no background or hairlight.

Madearis also uses a simple approach to how he poses his family groups. Regardless of which prop he uses to achieve it, he tries to design all of his studio portrait family groups to have a triangular composition. "I don't get hung up on the exact position of the arm or hand

"...learn the capabilities and the limitations of your camera room..."

Above: The perfect image begins with a perfect exposure. Always take an exact light meter reading from the subject to the camera, not from the camera to the subject. Photo by Ken Whitmire.

Below: Use your light meter to determine proper exposure. Here, you can either expose for the subjects and loose the beautiful tones in the sky, or you expose for the sky and allow the subjects to become silhouettes. Photo by Ken Whitmire.

Above: A close-up of the steps changes the look of his porch prop when doing individual or small groups. Photo by Roy Madearis.

Right: The black wrought iron fence is located to the left of the porch. It is an easy way to add a completely new look for photos of smaller groups or individuals. Photo by Roy Madearis.

Above: Positioning subjects twenty feet in front of the background and allowing space around family members are trademarks of this photographer. Photo by Mark Spencer.

Below: Use locations based upon the time of day and quality of light. If the client tells the photographer the location they want, photographer tells the client the time of day best suited for a session. Photo by Dennis Craft.

This photographer prefers to use props that already exist at the location. Here, he uses the family's house and lawn furniture as the props. Photo by Mark Spencer.

8-1 (right): Roy Madearis lights small groups the same as he does large groups, and his goal is even lighting with minimal shadows. This image was taken at the high key end of his studio. Photo by Roy Madearis.

8-2 (below): In this low key portrait, the photographer uses a painted background. Photo by Roy Madearis.

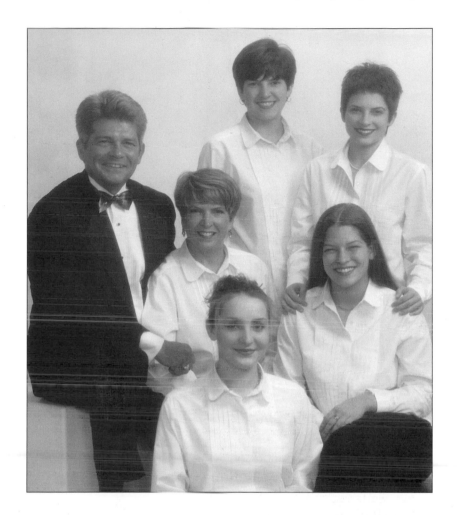

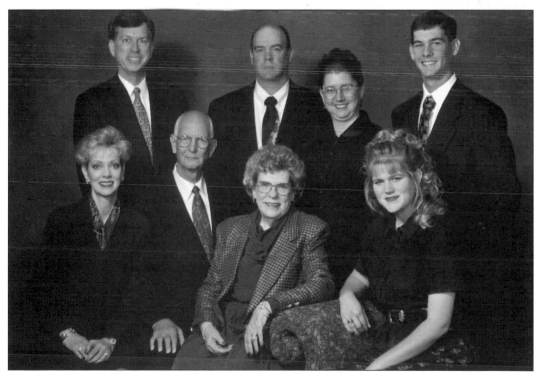

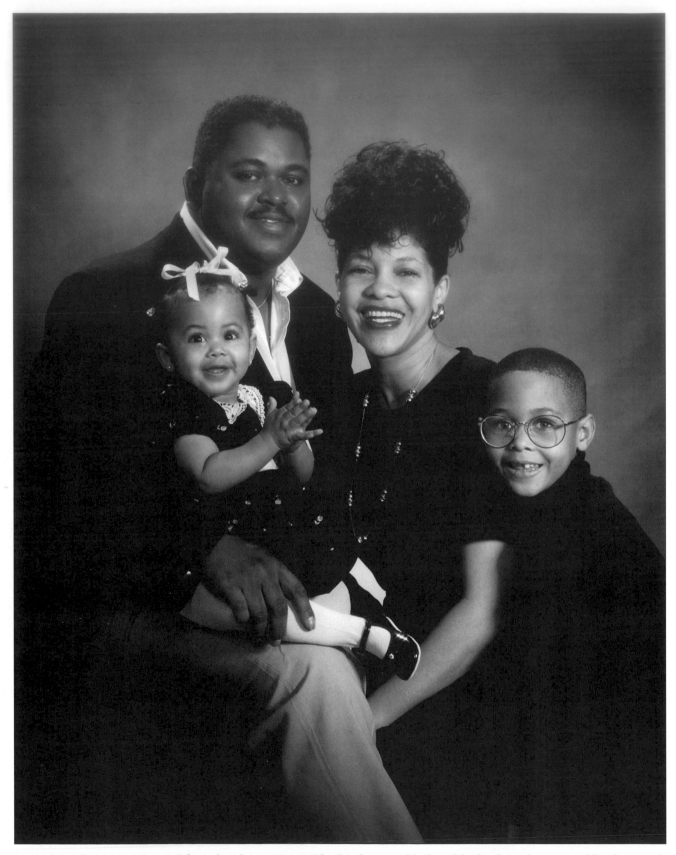

8-3: *The subjects are dressed for a low key portrait. The background light adds depth to the painted background, and a separation light enhances the detail in their hair. Photo by Horace Holmes.*

or where the head is. I try for even spacing between subjects so that two people — say mom and dad — are not separate from the others," he said. With two adults and one or two small children he may pose a full length series on the floor. If there are three or more adults, he takes all the images three-quarter length.

Horace Holmes prefers three-quarter length posing for family groups. He uses a Photogenic 600 for his main light and his fill light, and he has a fixed hair light. To add accent, he occasionally also uses a kicker light. He prefers the traditional high key image of white clothing against a white background, but lately he has also been leaning toward lightly dressed subjects against a dark background. He uses Kodak PRN100 (rated at 100ASA) with his Hasselblad 503CW motordrive unit with a 120 lens.

Ed Lilley uses a Dave Newman Master's Touch softbox which measures about 30"x30" with a Photogenic Powerlight 600 as his main light. He sets the output for ƒ11. He has a fixed fill light system which is three lights bounced off the ceiling at the rear of the camera room to give a very even ƒ8 reading across the subject area of the studio. When he wants to add a hairlight or background light, Lilley uses a Photogenic Studio Master II light metered to ƒ8.

8-4: The photographer's objective is to have a very controlled ratio of two to one or two-and-one-half to one, or an ƒ8 to ƒ11 difference if you metered the lights separately. Photo by Ed Lilley.

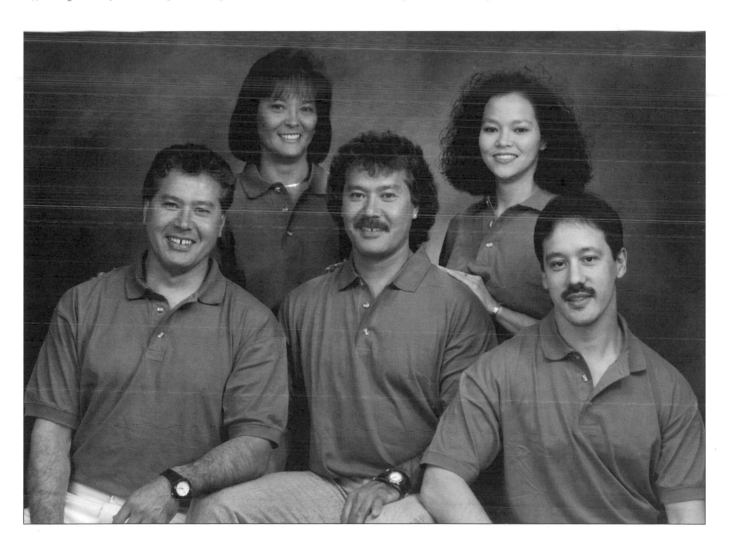

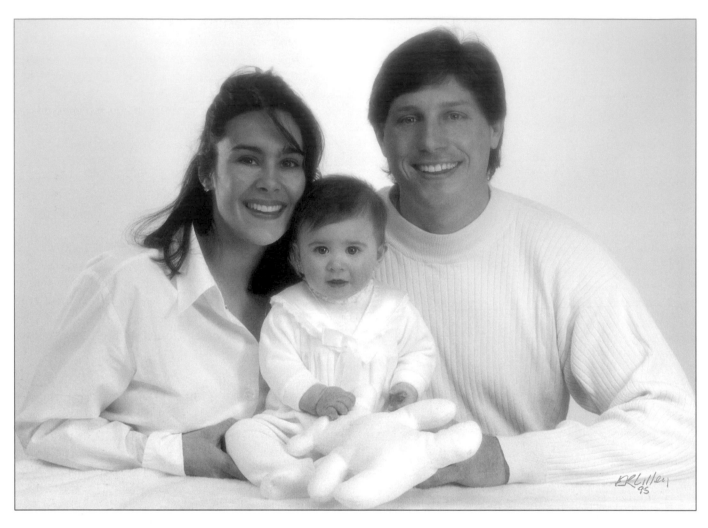

8-5: To make sure the requests don't get out of control, the price list explains that he will do up to four different groupings. Classic white on white high key style. Photo by Ed Lilley.

When he lights a large group of more than ten people, he uses a Photogenic light with a 16" parabolic on a rail system on the opposite side of the group as the large softbox. "The objective is to have flat light so the shadows within the group are down. It becomes almost like a copy lighting set up so the shadows within the group are at a minimum," he explained.

With all his studio groups, Lilley spends the most amount of time working with the entire group. He does two pose variations with everyone, one more compact and one a little looser. Then he photographs the core family (i.e. the parents with the adult children), the smaller families within the group, and all of the grandchildren together.

Mark Spencer said studio photography is fooling the eye into believing something is real and not staged. "It should be just like going to a movie and forgetting that you are watching actors and actresses playing fictitious characters in front of the camera," he explained, "I don't want my studio portraiture images to look contrived. I want them to look real."

To do this, he uses a 54"x72" Plume softbox with a Norman light head set at 600 watt seconds. When he is photographing less than three people, he uses a white reflector for the fill light. For three or more

people, he uses a fixed fill light which is a 1200 watt second light pointed into the junction of the ceiling and the wall behind the camera. With dark clothing against a dark background, he uses a Photoflex Halfdome softbox with a Norman light head. He said he uses a kicker light more than an actual hairlight because he likes a little bit of separation to show the outside edge of the body. He wants the background to be barely noticed, and he said he stays away from muslin drapes where you see every wrinkle and the image just screams "photograph."

Spencer said one of the most overlooked aspects of family portraiture is posing. He said most photographers build groups that conform to the traditional formula of the triangular format. He believes the arrangement of the bodies within the image sends a message to the viewer about the dynamics of the family. For example, if the little girl is seated next to the father, the viewer can infer that she is "Daddy's little girl."

He said he frequently adds space between older children to show their greater individuality. He rarely builds his groups into one large triangle, but draws his composition ideas from painted portrait classics. "The viewer can learn a wealth of information about the families portrayed in the paintings of the great masters. Elements are quietly inferred

8-6: This photographer likes the classical style of the Old Masters, and he aims to emulate it in his own work. Photo by Mark Spencer.

from studying the arrangement of the bodies, their expressions, the color scheme, the clothing, and the background," Spencer explained.

Spencer said the important point to remember in lighting studio portraits is to deliberately light each image. He explained, "We should use a light only when we have a need for it, like separating dark clothing from a dark background. Lighting is a tool. Learn what your lights can do, and then use the right tool for each job."

With 300 miles of sandy shoreline on Cape Cod, Boursier Photography clients rarely request a studio portrait for family groups. When they request the studio, it is generally because they want something very formal. I use a White Lightening 600 watt second main light bounced into a large silver umbrella or shot through a white Starfish. I prefer *f*11 for groups to get a better depth of field. I set the fill light for an *f*8.5 exposure, and I use a fixed overhead light for separation. I prefer a painted backdrop or a smooth muslin that looks like a painted background. My film choice for studio portraits is Kodak Verichrome Pan Black and White because it offers a beautiful range of tones and is particularly flattering to the faces. My objective with all my studio portraits is even lighting, simple posing, minimal props, and natural expressions.

8-7: Two sons were serving in the U.S. Marine Corps during the Gulf War, and they happened to be home for a short leave at the same time. The mother wanted a beach portrait because it represented the real them, but she also wanted something with the uniforms. We did a formal session in the studio and then switched gears for a casual sunset session at the beach. This portrait continues to be a great conversation piece as it hangs behind the counter at the father's bicycle shop. Photo by Helen T. Boursier.

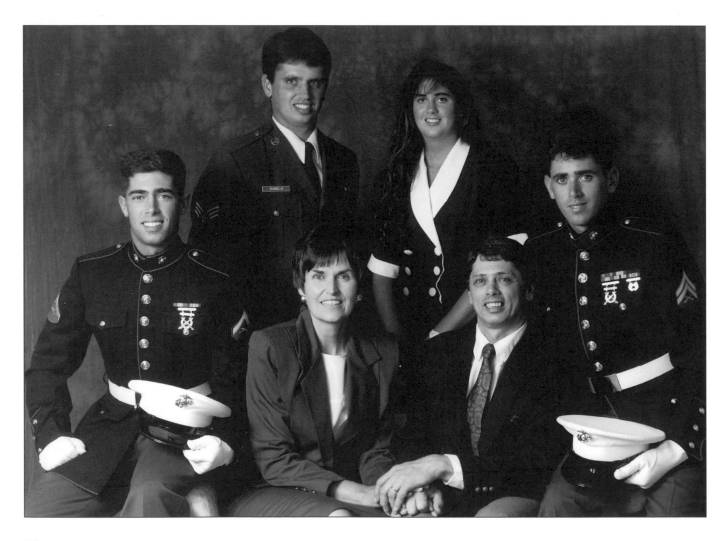

CHAPTER NINE

Photographing on Location

Photographing on location requires a whole new set of skills. Yes, you need to have skills in composition, line and design, but you also need to be quick, flexible, pay attention to detail, and have an intuitive sense of what will work and what will not.

"...have an intuitive sense of what will work and what will not."

Checking a Location

Ideally, you will have the opportunity to check out the location ahead of time, but realistically you will most often have to wing it upon arrival to the portrait session.

The trick is to keep your wits about you and stay focused on what you must accomplish, all the while making small talk with a group of people you barely know.

Occasionally, I have the chance to look over a new location in advance. I am happy to check it out just prior to the session because the light and wind conditions vary so much.

How I could use the location one day will vary considerably from another. I generally arrive 15 to 30 minutes ahead of the appointed time when it is a first-time location. I leave my camera locked in the car and walk all over the general area looking for two or three settings to photograph the entire group plus a few smaller sections to photograph the children.

My first consideration is the direction of the wind compared to the light because the wind can make or break a beach portrait. I must use the wind so it blows into the faces of my subjects. If it comes from behind their heads, their hair will look terrible and no one will want the portraits. Then I look for light quality and composition elements.

Light & Composition

Since I work only with natural light, I photograph either at dawn or dusk in what photographers call "sweet light." Ideally, I work literally just as the sun is rising or setting, but realistically I photograph several family sessions per evening so I must work with a broad range of light quality.

9-1: *I tell all my clients to expect wind at the beach. Generally, I position subjects so the wind is in their faces and gently blows the hair out of their faces. In this case, the wind was gusting to 25 knots so the hair looked wild. I reversed tactics and used the father and sons to block the wind from behind. You would never know how gusty the wind was that night! Photo by Helen T. Boursier.*

When the light is too harsh out in the open, I tuck my subjects down low in a sand dune (same concept applies to the shade at the edge of a row of trees). Then I expose for the shadow side of their faces and use the sand in front of them to serve as a "fill light."

The actual exposure reading is critical, and it is important to take the light meter reading directly off the face of the client on the shadow side of the shadow.

If you take the reading from camera angle by simple holding your light meter out at arm's reach, the eye sockets will often go too dark for an effect photographers call "raccoon eyes."

The composition element most important to me is an uncluttered "clean and neat" look. Some backgrounds are busier than others, for example a harbor compared to a field or beach, but I look for least cluttered area within the setting I am given.

I prefer to have something solid behind the heads of my subjects, such as beach grass, sand or a row of trees. In a harbor setting where the background is full of boats, I use depth of field to throw the boats out of focus as much as possible. People want the boats to be there, that is why they chose the harbor location, but they also want the family members to dominate the portrait.

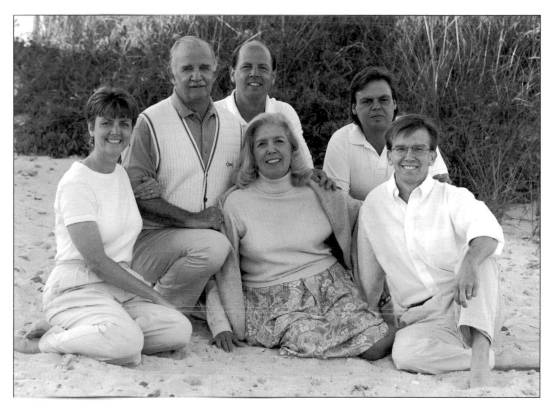

9-2: *The lighting was very harsh at the beginning of this family reunion session, so I started by using the soft shade of the sand dune. Photo by Helen T. Boursier.*

9-3: *This shot was taken right after photo 9-4 (next page). The subjects were positioned with the sun to the left, exposing for the shadows on the faces. Photo by Helen T. Boursier.*

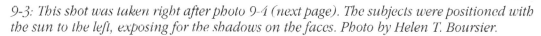

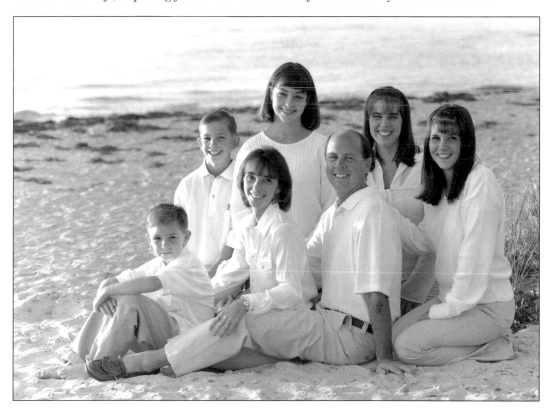

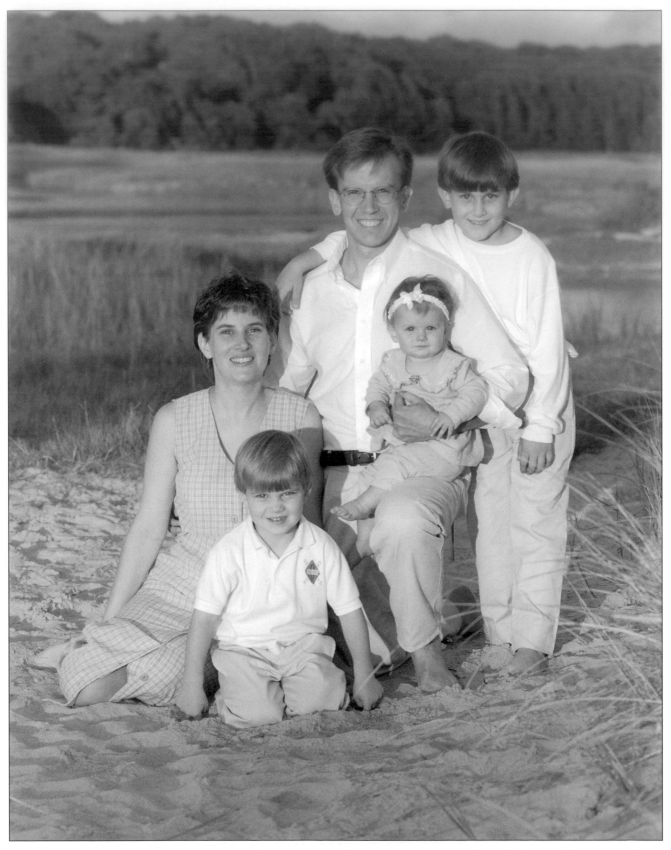

9-4: *This grouping was done immediately after photo 9-2. The sun is almost directly in the faces of the subjects here, giving the image a real "snap." Photo by Helen T. Boursier.*

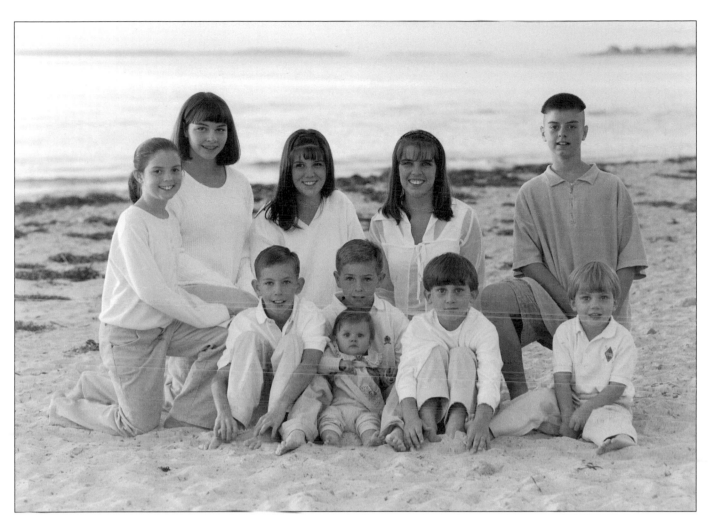

9-5: The "cousins" photograph was taken just as the sun was setting. The lighting is similar to photo 9-3 (page 73), but the sun had softened considerably so the lighting ratio from highlight to shadow is also much softer. Photo by Helen T. Boursier.

Mark Spencer looks for an ideal background that a portrait painter might have used a century or two ago. He pointed out that painters only put into the image exactly what they wanted to see and not necessarily what was actually there. Photographers must carefully look through the viewfinder, looking for individual trees or fence posts, or a wayward tree branch that doesn't belong in the image.

Spencer wants the background to be well in the distance, preferably at least twenty feet away. He breaks the background into basic elements like shape and line.

For example, a shape could be one big tree and even a row of trees. "If you see one big tree sticking out of nowhere, that tree doesn't belong in the image," he explained, adding, "You need to choose a different angle or a different focal length or a different position or you need to relocate."

He said composition lines are shapes that come together to form some sort of line like an "S" or "C" curve. His favorite lines are either leading lines that lead you to the subjects or perspective lines that give a sense of depth and distance.

Marg Straw calls this a "tunnel," her ideal background location. "I look for anything that creates a tunnel effect. It might be a line of trees

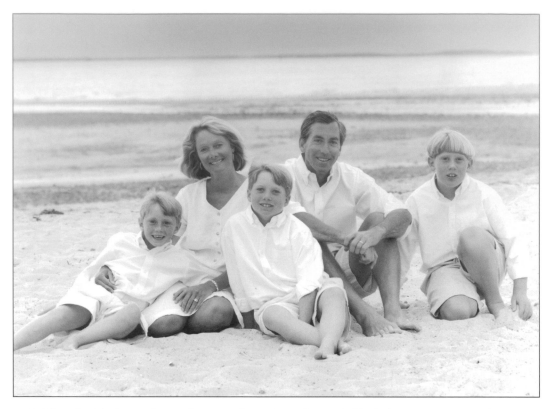

9-6: *The ideal lighting for working exclusively with available light comes just as the sun is setting. Notice the even lighting and the detail in the whites. Photo by Helen T. Boursier.*

9-7: *Sunrise lighting is ideal for available light portraiture. Early morning fog is common and works beautifully to soften the background. Photo by Helen T. Boursier.*

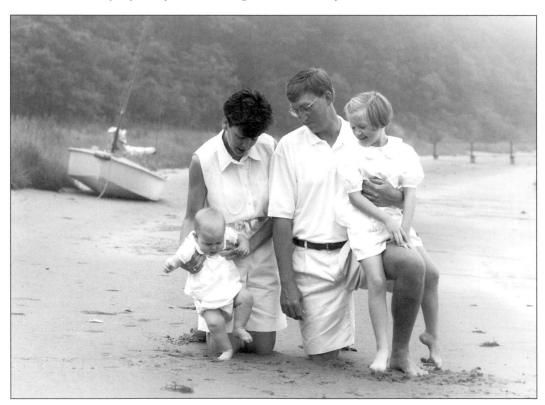

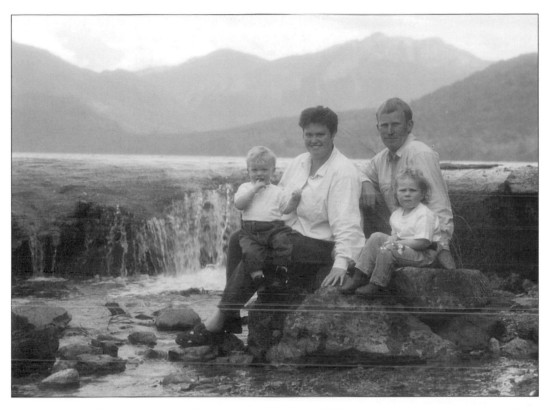

9-8: *Straw prefers to use available light, but will use a fill flash metered at no more than f2.8 if she needs to enhance the light in the eyes of the subjects. Photo by Marg Straw.*

9-9: *Straw looks for a background which creates a tunnel effect similar to off-setting a row of pillars or trees. She likes the depth. Photo by Marg Straw.*

9-10: A mid-day session photographed in heavy shade. He likes the circles of confusion in the background, but he makes sure there are no tree branches sticking out behind his subjects' heads. He also makes it a point not to show any sky, since it would be too bright. Photo by Dennis Craft.

that angles back behind the subjects. This is the same concept as working with a row of columns in front of an elegant building. You don't just line the columns up one behind the other. You use them slightly at an angle so you have converging lines," she said, adding that ideally the light is the same at the beginning of the tunnel as it is at the end of the tunnel.

Dennis Craft of Marshall, Michigan searches for a solid background with no distracting elements, and he prefers to create light patterns by working with open sky and no artificial light.

He has locations he can use from sunrise to sunset. He said, of course, at noon, he must work in heavy shade, but he still has locations that work for him.

He uses Kodak PPF 400 (rated at 320 ASA) because he likes the contrast options the film offers. "If I choose to use a little diffusion, I can still do that with PPF without mushing up the image," Craft said. He uses the Mamiya RB67 with the 180m lens for most of his family groups.

For a large family, he relies on the 127m lens. He explained, "With a real large group, I use the wider lens because I still need to have contact with the kids. A two-year-old doesn't want to communicate with someone in the next block!"

Ed Lilley begins photographing 2½ hours before sunset, scheduling two family sessions of forty-five minutes to an hour and one half-hour session for a small family with other children who can sit still (or a couple or a bride). He saves the best time frame, one-and-one-half hours before sunset, for the largest family group.

Fill Flash verses Available Light

Lilley said the perfect light comes on a humid night with a heavy haze. "If you can look at the sun directly and not burn your eyes, you've got good light," he said. Then he uses the sun as a main light source directly into the subject's faces or slightly off to an angle. That represents only about ten percent of his shooting time. The other ninety percent of the time the light is too harsh so he uses fill flash.

He faces the subjects away from the sunlight so they are backlit or partially backlit. That creates an accent or "hair light" and the flash becomes the main light. He uses his Metz 60CT-4 portable flash unit as the primary main light. He adds a Quantum Q flash on a light stand with a remote infrared trigger as a secondary light for a medium to small group.

9-11: Lilley explained, "The problem on a bright sunny day is that the Metz or the Quantum need to be at f16 with the shutter speed at 500th of a second. The Quantum just doesn't put out that much power, but the Metz does." Photo by Ed Lilley.

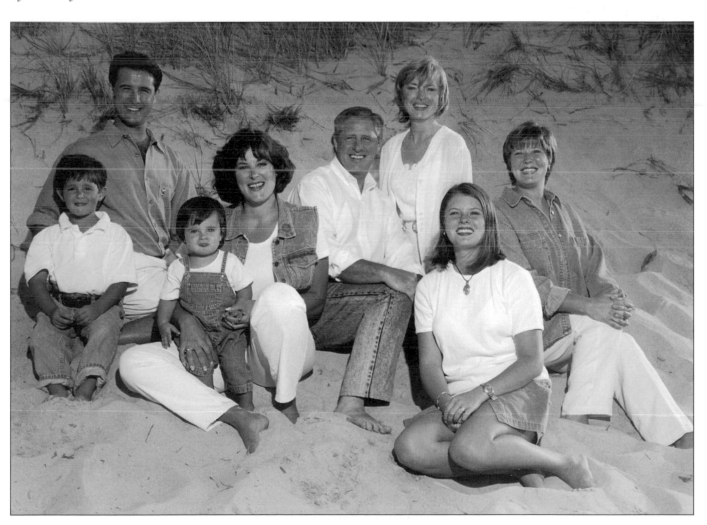

9-12: He uses the Quantum on smaller groups because he can move in close enough to be effective, and he positions the Metz from camera angle to become the fill light. Photo by Ed Lilley.

He said another common situation is to get an overcast night where you can't see the sun. There is soft light, but no shadows, so the light quality is flat and dull.

Then his flash on camera becomes the fill light, and he uses the natural light as the main. He sets the flash output to match the exact exposure of the ambient light so it puts a little snap in the picture without casting a shadow.

"This is what you term 'fill flash.' It is a very flat light source, but it gives the image just the kick it needs. You notice the difference in the eyes. Also, the colors are better without being washed out. The ambient light takes care of any shadows," Lilley explained.

When Bob DiCaprio of Woonsocket, Rhode Island requires auxiliary light, he uses the bare bulb technique with a Lumedyne strobe head.

He meters for the available light, and then he sets the output of his Lumedyne battery pack so it is no more than one stop above the ambient reading, making the strobe the main light.

If it is a nice quality natural light, he uses the Lumedyne output by matching the exposure reading of the available light to literally "fill" in the shadow areas of the face (i.e. the eye sockets). "The bare bulb technique gives you the most non-directional source of light," DiCaprio said.

9-13: On the larger groups, the Metz is the light source, and he uses it straight on to maximize output and also minimize shadow. Shadows are inevitable because of the huge difference between the exposure in the bright sun behind the subjects and exposure on their faces before the flash. To minimize the fall-off shadows from the subjects when he uses the Metz main light, Lilley positions the subjects at least five feet in front of any stationery background object (i.e. a rock, house, or dune) so the shadows fall on the ground, making them less noticeable. Photo by Ed Lilley.

To properly use the bare bulb technique, you use a flash unit, like the Lumedyne, where the flash tube is exposed with no reflector around it so the light goes out in all directions around the tube.

Depending upon the strength of the lighting unit, subjects can be about ten feet from the light source. Point the strobe sideways so the tube is parallel to the ground.

DiCaprio's unit has output choices of 100 watt seconds, 200 watt seconds and 400 hundred watt seconds, and he generally uses the 200 or 400 setting.

He uses a Minolta Auto 3 light meter, and he sets it at 250th of a second, regardless of the actual shutter speed he will be using to take the photograph. DiCaprio said the 250th setting minimizes the effect of available light on the exposure reading so he is able to get a reading that is as accurate as possible to calculate what the strobe output should be.

Roy Madearis said photographers should not get so focused on the location that they forget the people.

He said it is important for photographers new to photographing families to find a really good location and then concentrate on getting one or two decent looking pyramid type constructions of the entire family group.

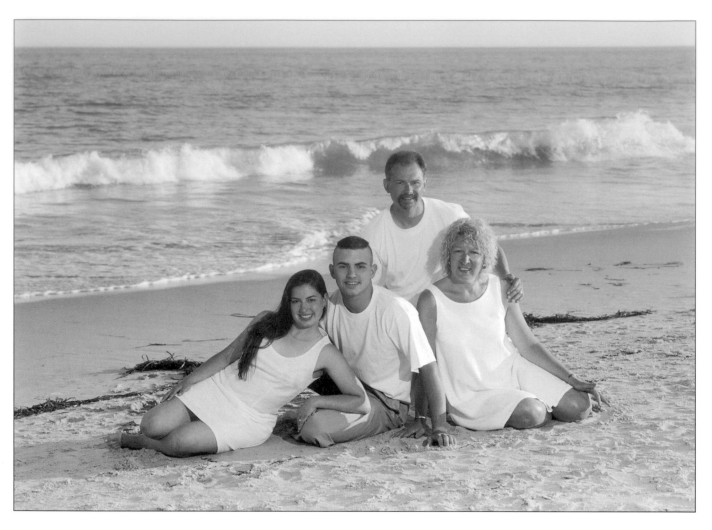

9-14: The Lumedyne becomes the main light source in this image which had to be taken long before the light was soft enough at the beach. Photo by Bob DiCaprio.

Madearis added, "Do not try to do so many variations that you don't get any good images of anything! If you do ten different variations, you will run into problems. Go for expression. Expression is what people want."

CHAPTER TEN

Photographing at the Client's Home

Using the client's home as a backdrop for their family portrait adds a whole new dimension to the image because of the memories the setting creates. In the mobile world today, it is not uncommon for families to move to new neighborhoods, new cities, new states, or even new countries.

When you photograph at the home, whether indoors or out, you are helping the family to remember a slice of life they might some day leave behind. Even for families who do stay at one home for thirty or forty years, an at-home portrait will preserve what their house looked like when the family members were a particular age.

I often travel one or two hours to photograph clients throughout Southeastern Massachusetts. I generally meet clients at their home before going to the designated park or beach for the portrait session. I always suggest we do a few images of the family with the home as a backdrop first. It only takes about fifteen minutes to scope out the location, set up the camera and pose the group.

I love the combination of pride of family and pride of home ownership. The two blend together beautifully for a portrait that is far more personal and more memorable ten, twenty, and thirty years down the road. Many clients still choose the images from the beach as their primary portraits, but they always appreciate being able to purchase at least one from the home session.

Bob DiCaprio does most of his family portraits in the client's home. He prefers to go to the client's home a week or so prior to the session so he can scout the location and talk with the client. He asks which room they prefer, where they plan to hang the portrait, and whether they see the image as horizontal or vertical. He said it is surprising the number of people who have never thought about where they are going to hang their portrait.

He said he takes the time to move furniture and props to remove any distractions and keep the focus on the family. He likes fireplaces where

"...helping the family to remember a slice of life..."

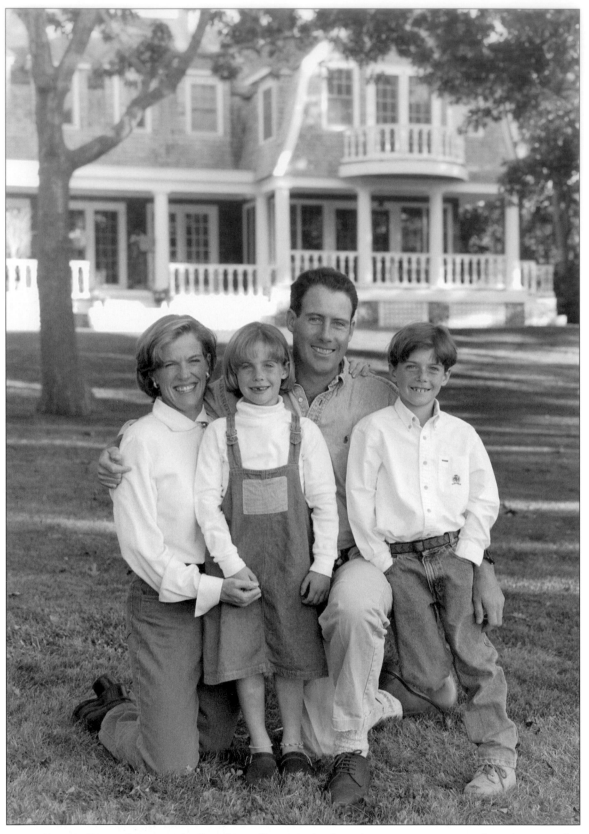

10-1: To put the emphasis on the family and to give depth to the image, I position the subjects as far away from the house as possible. I pose the clients on the ground in a shaded area of the front lawn and expose for the shadow side of the faces. Photo by Helen T. Boursier.

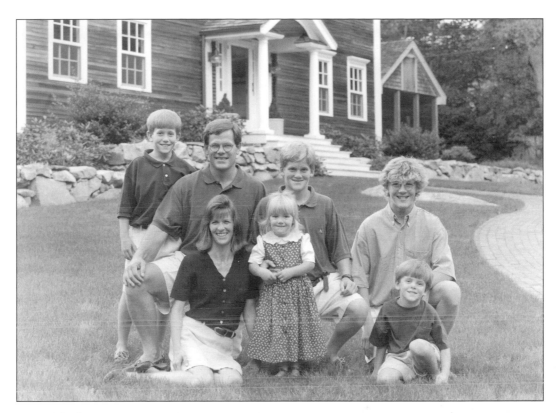

10-2: *The house is close to the exposure of the subjects. The exposure of the subjects must be perfect; the density of the home can be changed during printing. Photo by Helen T. Boursier.*

10-3: *With a wide angle lens, position the subjects in the foreground. Use a low camera angle to make the converging lines of the architecture less noticeable. Photo by Dennis Craft.*

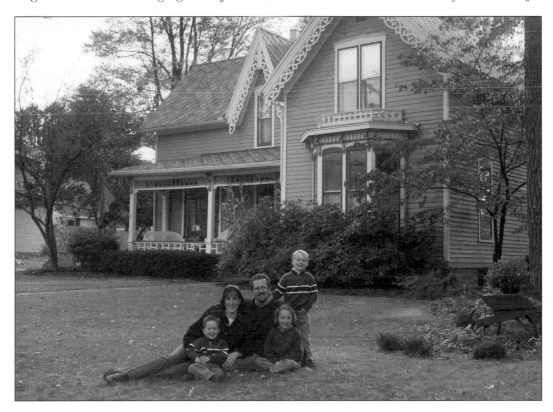

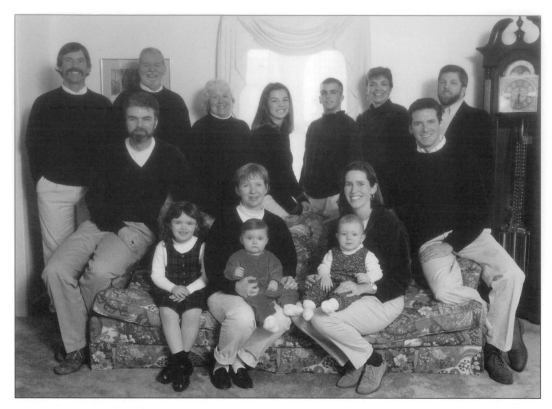

10-4: *It was much easier for this large group to be photographed in their home than to go to the studio or on location. The image was lit with one Powerlight 600. Photo by Bob DiCaprio.*

10-5: *This family designed their home. Since they were particularly pleased with the fireplace, it was used as an integral part of their family portrait. Photo by Bob DiCaprio.*

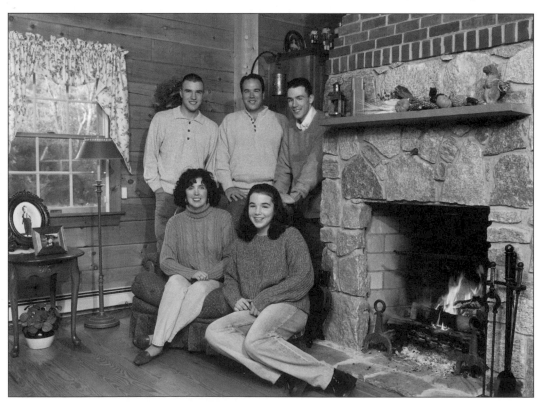

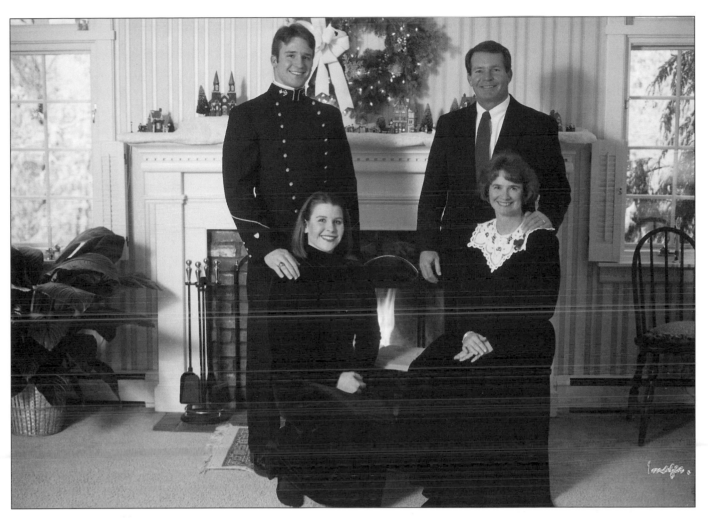

10-6: *Formal clothing requires a formal setting and formal posing. The completed portrait ultimately was hung over this fireplace. Photo by Bob DiCaprio.*

he can start a fire, and he avoids using anything in the foreground. He works with what the clients have, with the existing environment. He wants to show off the home as it is.

DiCaprio tries to have his subjects five to six feet away from the background if possible. He generally uses only one light for the subjects, a Powerlight 600 on a light stand bounced into an umbrella. He takes an ambient light reading, particularly for the rooms that are going to show in the background of the photograph. He will use a 500 watt blue bulb (balanced for daylight for indoor photography) that he clamps to the light stand with the Powerlight to bring the room light level up so the ambient reading is f5.6 at 15th of a second. He adjusts the main light for f11. He might use the modeling lamp from a second Powerlight to increase the ambient light reading, but the subjects are always lit with only one light.

When Randy Taylor of Edmond, Oklahoma photographs in clients homes, he wants to represent what the people see on an every day basis. He looks to see where the light is coming from, and then he matches it within the portrait. "If the mother is used to seeing the shadow on the right side of the lamp, then you want to keep it there," he explained. "For the posing, I want it to be as natural as possible. If

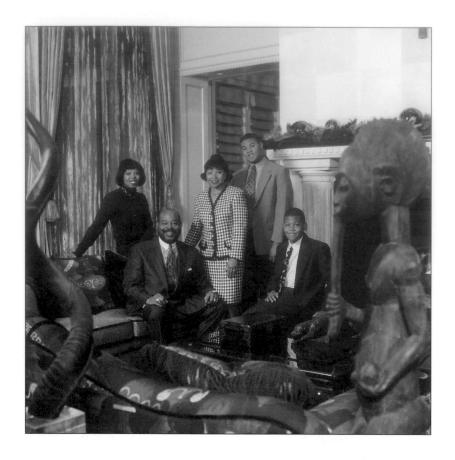

10-7: *All of his images include a foreground, a middle ground, and a background. He avoids flat walls, and he avoids shooting straight into a fireplace. Photo by Randy Taylor.*

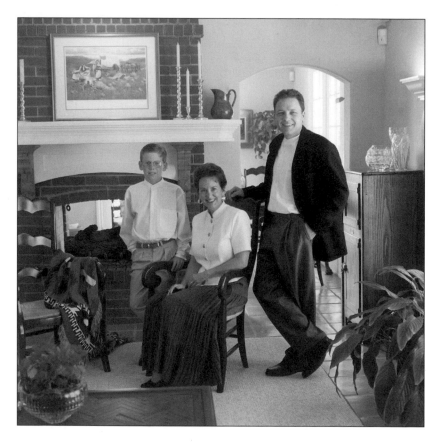

10-8: *If the home limits the amount of depth he can show within the home, he includes a window and changes the base exposure for the outside light, hopefully by simply adjusting the shutter speed. Photo by Randy Taylor.*

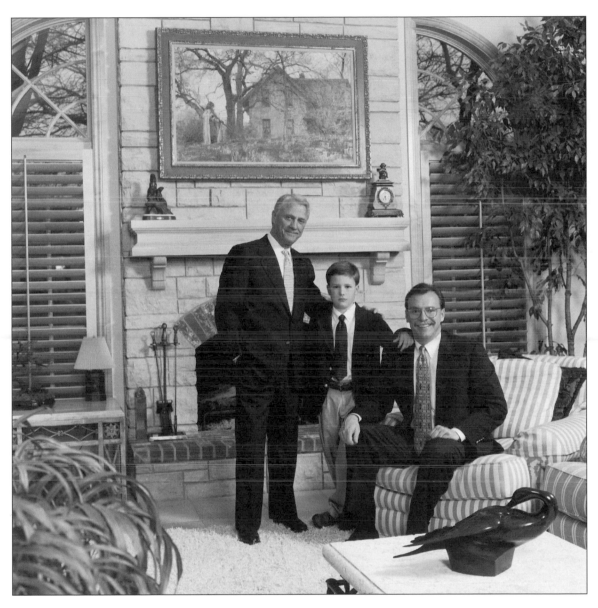

10-9: *Use the fireplace as a design element, and try to get furniture away from the walls. Photo by Randy Taylor.*

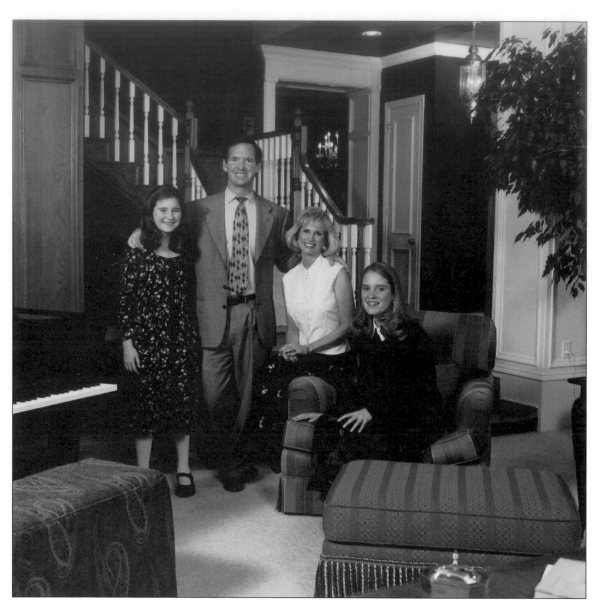

10-10: Ottomans, pillows, sofas, and special pieces of artwork make nice foregrounds. Photo by Randy Taylor.

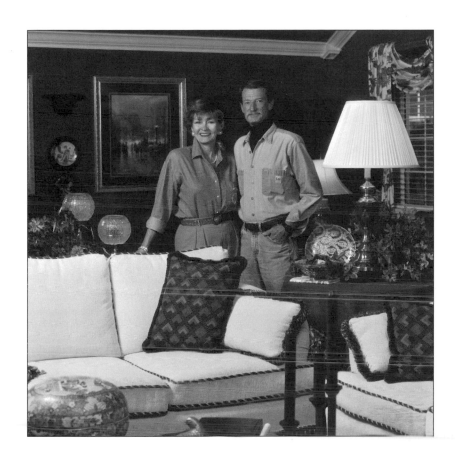

10-11: An assistant is helpful to prevent light from spilling onto the foreground. Photo by Randy Taylor.

10-12: Randy Taylor said some clients call asking for an in-home portrait, but in talking with them he discovers they are really outside people. He likes the "slice of life" home portraits capture. Photo by Randy Taylor.

they are feminine, I want them to look feminine. If they are masculine, I want them to look masculine. I want them to look natural and comfortable."

His favorite foreground is a plant or the corner of a sofa. He also likes to use special pieces of artwork in the foreground or colorful pillows. He said it is important to make sure you slightly blur the foreground and to avoid letting any fill light fall onto it.

Taylor said he will often have his assistant stand so his own shadow falls across the items in the foreground. "I do quite a bit of moving things around. I don't want furniture to be right up against a wall, and I use a fireplace as a design element and not the background," he said, adding that it is important to take your time when you look through the viewfinder.

It might take him as long as half an hour to get the room and lighting set up to his specifications. He gets the adults involved in this phase, and he takes a Polaroid once the set is ready to make sure everything is perfect. Taylor once discovered a huge can of hair spray sitting on the mantle that no one noticed until the Polaroid was taken.

Taylor sets up and lights only one area of the home, but he changes angles and lenses within that setting to add variety to the selection of images. "If you keep your camera angle and your lens the same for every image, they are going to look boring. You don't want to just swap out people and have everything else the same," he said. Taylor changes the perspective so the portrait and the background look different.

He said to remember that people buy the experience as much as they buy the product. "When you're out there, have fun with the client. Talk about their belongings, their decor, their family. Get them thinking about where they will display the portraits. Don't rush in, get the job done, and rush out. Take the time to get to know the family," Taylor advised.

CHAPTER ELEVEN

Presentation Options

There are almost as many ways to show clients their proofs or previews or originals as there are ways to light the portraits. Today's choices include contact sheets, paper previews, opaque projector, negatives projected to a television screen, slide proofs, video projection, digital or as completed portraits with the photographer deciding the best poses. There are pros and cons of each variation.

Contact Sheets

Contact sheets are generally used by photographers who use black and white film and want a quick and inexpensive way to show clients the images. The images are the exact size of the negative, which makes them very small for anything more than head and shoulders portraits. Although they are inexpensive to produce and easy to mail, it is difficult for clients to visualize finished work from such small images.

Paper Previews

Paper proofs or previews are one step up. They are printed as first run photographs in the same format as the camera used to take the images. For example, 35mm are 3½x5, square format Hasselblad are 5x5, and the 6x7cm Mamiya RB67 images are printed 4x5. Previews are most commonly used for weddings, seniors and children because they can easily be mailed to the clients homes. Photographers who have clients who live long distance will also use previews for family portraits. The two main drawbacks are the small image size and the easy availability for anyone to make poor quality cheap copies at a photo copy station.

Because of the rapport I have with my clients, I am not worried so much about them copying the images as I am worried about how difficult it is to decide size and shape and crop with all the faces so small in a 4x5 paper preview.

Opaque Projectors

Some photographers get around both limitations by keeping the proofs in the studio, and using an opaque projector to show what larger

"...it is difficult for clients to visualize finished work from such small images."

11-1: Randy Taylor uses 5x5 paper proofs, and he uses the many examples in his front galley to help clients visualize size. Photo by Randy Taylor.

sizes look like. Fotovix is popular for studios who want to save the price of having slide proofs or paper proofs made. The film is processed, and the images are projected on the Fotovix to a television monitor. You can project the images as large as your TV screen allows. This method cuts back on your cost of goods sold, but it requires that you handle the negatives over and over throughout the presentation of the images.

Slide Proofs

Slide proofs ("transviews") are produced from your usual professional negative films. Instead of having paper proofs printed, the negatives are copied onto 35mm slide film. The lab returns the processed negative film in the usual manner with a box of slide proofs instead of a stack of paper proofs. Clients view the images by appointment at the studio.

I prefer this method because it enables me to show my clients literally every size, shape and crop from 4x5 to 40x60. There is no guessing, no imagining. They can see it exactly the way it will be once the portraits are made up. To offset the drawback that clients must gather at the studio to view the images, I tell my clients they only have to come to the

•**The primary advantage to slide proofs is that you can show clients every size, shape and crop.**

94

studio to view the slides. I will go anywhere they want for the portrait session, and we offer free shipping for the completed portraits.

Video Projection

Video projection takes the slide proofs one step further, and Peter Straw prefers this presentation method. After using slide proofs for many years, he wanted to keep a similar presentation style but delete the cost of having the slide proofs made. "My main criteria was that I did not want to change the sales session format I was using. It was productive and getting the results I require from my sittings. I also wanted our clients to retain a great and fun method of deciding on their image and size," Straw said, adding, "I like the clients to see large images to pick the best expressions, and I like being able to project any size they wanted. I also wanted to be able to project into any frame style so they could get a very good idea of the finished product. All these benefits of transviews were important not to loose."

Now a local lab processes the film. Then Straw scans the images into the computer and then to a video projector. He explained, "Now if a client needs to see their images urgently, they could easily have a coffee

11-2: This family chose a 24x30 portrait to hang over the fireplace in their formal dining room. The slide proof projection appointment enables clients to see exactly the size and shape of the portrait before they make the final selection decision. Photo by Helen T. Boursier.

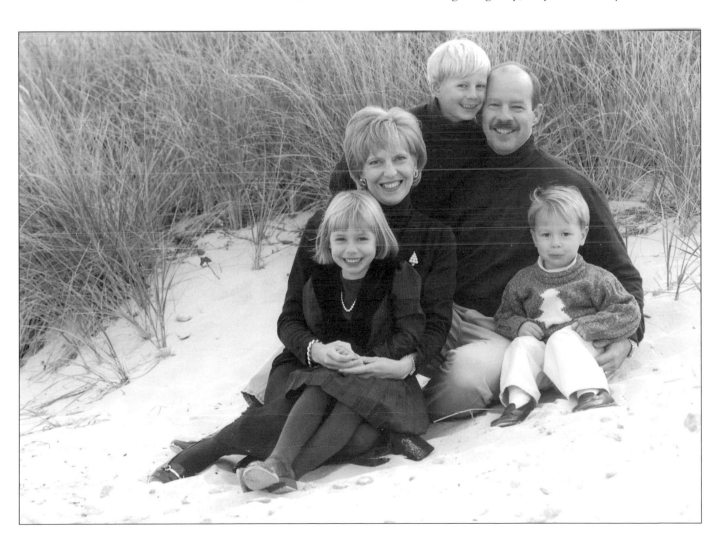

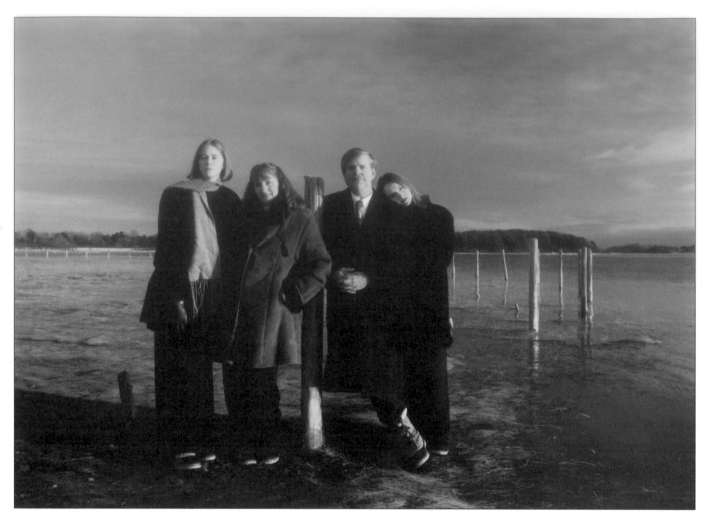

11-3: It sometimes requires a little juggling of schedules to get everyone back in to view the slide proofs, but Goldsmith's clients say it is always worth the extra effort. Photo by Jay Goldsmith.

while the film is processed and scanned. Then they can see their projected images via the computer video projection."

Digital Projection

Digital projection requires that the images be taken with a digital camera. Some have the capability to use traditional negative film in addition to a computer type back.

Other cameras are 100% digital with a negative made from whichever poses the client ultimately orders from. This method requires someone to operate a computer while presenting the images to the client.

It is the ideal method when immediacy is a must because clients look at the images literally right after the photography session. Digital is definitely the trend of the future, and most photographers will be using it, at least to a certain degree, very soon.

The biggest drawbacks are the high learning curve and the high initial investment for equipment. Also, with the rapid changes being made by manufacturers in the computer field in general, what you purchase is out of date almost as soon as you unpack it from the cartons.

"Presenting the portraits as a finished product is another option."

The Finished Product

Presenting the portraits as a finished product is another option. Although I have not yet tried this method, I've talked with several photographers who use it with great success. The concept is the client commissions the photographer to create a piece of art, much like a portrait painter has been commissioned for centuries. The photographer takes a series of images and creates the final portrait(s) based upon which image(s) best reflect the quality of work and personality of the family group.

When we were lecturing in New Zealand, Marg and Peter Straw photographed our family against the backdrop of the South Island. It was not logistically possible for us to view the images before we left the country, so the Straws made the selection on our behalf. Several months after we received the canvas wall portraits, we did see paper proofs of the other poses. The Straws did a perfect job choosing our portraits. There was nothing I would have done differently. It was wonderful to let a professional make the portrait selection for us. We enjoy the benefit of their expertise, and they did all the work.

Types of Products to Offer

In addition to deciding which method of presentation you will use for your clients, you must also decide which types of products you will offer. Then, create a series of samples to show what you want to sell. This might sound pretty simplistic, but the concept works.

In the late eighties, when we were gradually phasing out of color and into black and white portraiture, we took down all of our color portrait samples when the lab deadlines came and went for Christmas ordering. We filled our walls with black and white portraits and continued to accept

11-4: *The small subjects would be lost in this image with a 4x5 paper proof, but they come to life when projected on the wall with the Straw's new computer projection system. Photo by Marg Straw.*

11-5: For promotional "A Day in the Park" sittings, the poses are "proofed" as 5x7 photographs. One is included with the sitting fee. Clients typically buy a wall portrait, Christmas cards, and the extra 5x7 proofs for an average sale of $550. Photo by Michelle Schmidt.

orders right down to the last minute. It worked so well for Christmas, that we never put our color samples back on the walls. Yes, we continued to photograph in color for a few more years, but since clients didn't see any color, they rarely asked for color.

We have the opportunity to visit studios all over the world when we are on the road lecturing. It is not uncommon for a studio owner to wistfully comment, "I wish we did more outdoor family portraits," or, "I wish we got more requests for black and white." The answer is usually staring them right in the face. Their studio walls are filled with what they don't want to do, and there is almost nothing representing what they do want to photograph!

Ken Whitmire is a wall portrait photographer. Period. That is what he loves. That is what he shows. That is what he sells. Everything about his business reflects his passion for wall portraits. He said if all photographers would put high quality wall decor images out in the community for display, then the desire for photography as wall decor would climb. "When I hear someone say they can't hang a portrait of their family on the walls, I get chills down my spine," he said.

Whitmire asked how can we not want our family on the wall? What could be more desirable than seeing our loved ones on the wall? He

pointed out that we work for our families. We also buy furniture for our families. What piece of furniture could be more important in our homes than something that shows why that home is there in the first place? People who love portraiture as wall decor, love Whitmire's work.

Boursier Photography offers several portrait concepts to suit the varying tastes of our clients. The concepts include framed wall groupings of three hand colored or classic black and white portraits; a mat collection with one to five 8x10 and/or 5x7 portraits matted and framed as one piece; our "miniature masterpiece" canvas collection of up to five 11x14 and smaller canvas portraits that are individually framed then connected so it hangs as one piece; album collection in three sizes (4x5, 8x8, 8x10); and the a la carte concept where each frame and each portrait are purchased individually.

Each concept offers five choices; most clients choose one or two different concepts. For example, they might choose a wall portrait grouping for the living room, and a mat collection for the bedroom. I have a sample of literally every variation so clients can see what their choices are. "Show and tell" got most of us excited during our elementary school years. The same concept will get you and your clients excited about how they can best enjoy your beautiful portraits in their homes.

11-6: Family portraits freeze a slice of life and make time stand still. We've heard many clients lament, "Why did we wait so long? We should have done this sooner!" Photo by Helen T. Boursier.

Appendix

A special thank you to the following contributing photographers:

Helen T. Boursier
Boursier Photography
74 Carol Avenue
E. Falmouth, MA 02536
(508)540-3950
boursier@capecod.net

Dennis Craft
Craft Photographic Gallery
111 N. Grand
Marshall, MI 49068
(616)781-8907
craftphoto@aol.com

Bob DiCaprio
Images by Bob DiCaprio
1066 Diamond Hill Road
Woonsocket, RI 02895
(401)765-0122
cappie2@Juno.com

Jay Goldsmith
Goldsmith and Russell Photography
32 Cottage Street
Portsmouth, NH 03801
(603)431-4139
jayjulia@aol.com

Charla Holmes
Holmes Photography
514 West 2nd Avenue
Corsicana, TX 75110
(903)872-2533

Horace Holmes
Horace Holmes Photography Studio
352 Cotton Avenue
Macon, GA 31201
(912)741-5151

Ed Lilley
E.R. Lilley Photography
500 Main Street
Harwichport, MA 02646
(508)432-2266
crlphoto@capecod.net

Roy Madearis
Madearis Studio
1304 W. Abram
Arlington, TX 76013
(817)469-9001
madearis@onramp.net

Michelle Schmidt
Michelle's Studio of Photography
122 Hamel Road
Hamel, MN 55340
(612)478-9851

Mark Spencer
Carriage House Photography
2 Elm Square
Andover, MA 01810
(978)749-9593
carriage@shore.net

Marg and Peter Straw
Beverly Studios
Box 712
Christchurch, New Zealand
pstraw@cyberxpress.co.nz

Randy Taylor
Taylor Made Photography
1130 SW 15th Street
Edmond, OK 73013
(405)341-5088

Ken Whitmire
Whitmire and Wolfe
Eight North 8th Avenue
Yakima, WA 98902
(509)249-6700

Supplier List

We use the following list of suppliers for assorted wholesale items. Call or write for information.

Oval mounts to mask over slide proofs:
Jiffy Mask
The Kinney Co.
Box 1229
Mt. Vernon, WA 98273

Canvas supplier (mounting and/or materials):
Tara Materials
Box 646 — 111 Fredrix Alley
Lawrenceville, GA 30246
(404)963-5256

Bubble wrap (for shipping completed portraits):
National Bag
(800)247-6000

Corrugated boxes/office supplies:
Quill Corp.
(800)789-1331

Christmas cards/stationery for photographs:
M&M Designs Inc.
Houston, TX
(713)461-2600

Frame corners:
Gemini Moulding Inc.
(800)323-3575

Larson-Juhl
(800)438-5031

Custom cut matting:
Light Impressions
(800)828-6216

Pre-cut custom looking mattes:
Crescent Cardboard Co.
(800)323-1055

Full service b&w labs:
Filmet
2103 Hampton St.
Pittsburgh, PA 15218
(412)731-1600

Sound Color
Harbour Pointe Bus. Ctr.
4711 116th St. SW
Mukilteo, WA 98275
(800)426-9262

Specialty b&w custom lab:
Jonathan Penney — Darkroom Services
6 Adelaide Park
Center Moriches, NY 11934
(516)874-3409

For information on Helen Boursier's current speaking/
workshop schedule, contact:
 Boursier Publications
 FAX (508)540-6243

Other Books by Helen T. Boursier

Black & White Portrait Photography (Amherst Media)

The Modern (Hand Tinted) B&W Portrait (Studio Press)

The Studio Sales Manual (Studio Press)

Marketing Madness (Studio Press)

Tell It With Style (InterVarsity Press)

The Cutting Edge (Boursier Publications)

Interviews with Forty Photographers (Boursier Publications)

Top Ten Marketing (Boursier Publications)

Glossary

Aperture: Photographers commonly refer to this as f/stop. It is the opening in the lens that admits light.

Available Light: The existing light, natural or artificial, indoors or outdoors, that is already there. Photographers use available light as the primary source to light the subject or as the secondary source to fill in the shadows.

Back Light: The available light coming from behind the subject and shining directly toward the camera.

Bounce Flash: A technique of softening the light from a flash or strobe unit by directing it to a ceiling, wall or off a piece of photographic equipment like an umbrella or a soft box.

Depth of Field: The area of acceptable sharp focus in a picture. It includes the area in front of and behind the subject that is in focus. Many portrait photographers prefer a shallow depth of field, often just the eyes or the face of the subject to enhance impact.

Diffused Light: Light loses some of its intensity when it passes through a transparent or diffused material. Heavy overcast skies diffuse the light from the sun, for example.

Exposure: The total amount of light allowed to pass through the lens to the film as controlled by the aperture size and the shutter speed.

Film Speed: A film's sensitivity to light, rated numerically. The higher the ASA film speed rating, the faster the film. Faster film requires less light to create exposures on the film.

Filter: A thin sheet of glass, plastic or gelatin placed in front of the camera lens to change the appearance of the image as it is being recorded in the camera.

Fill Flash: An expression that means to slightly fill the shadows in an outdoor portrait.

Flash: A very brief but intense flash of artificial light.

Grain: The granular texture that appears to some degree in all processed photographic materials.

Handcoloring: Adding color to a black & white photograph by hand with pencils, pastels, watercolors, wet dyes, dry dyes or oils.

Key: A term used to describe the tone or colors of a photograph. High key refers to an all light or white setting. Low key refers to an all dark or black setting.

Kicker Light: An accent light where one side of the subject is illuminated more strongly than any other area of the image. Sometimes referred to as a rim light.

Rim lighting: A form of lighting where the subject appears outlined with light against a dark background. It is often used to accent one side of the subject.

Shutter: The camera mechanism that controls the duration of the exposure. A slow shutter speed means the subjects must sit very still or their movement will cause the image to look out of focus and blurred.

Silhouette: When a person or object is photographed against a strong light, the resulting black image is a silhouette.

Slide Proofs: The method many portrait photographers use to show clients proofs. The lab takes the processed film (35mm or 120 format) and copies it onto 35mm slide film. The slides are projected on the wall for easy viewing and pose and size selection. Then the negatives are used to make the enlargements.

Soft Box: A soft fabric box (usually flame resistant nylon), with a transparent front, that contains an electronic flash unit. It produces a "soft" natural looking light for photographing models.

Soft focus: Deliberately diffusing or blurring the definition of an image, usually to create a dreamy or romantic mood.

Stop: A comparative measure of exposure. Each standard change of the shutter speed or aperture represents a stop and doubles or halves the light reaching the film.

Transviews: Another word for slide proofs.

TTL: The abbreviation for "through the lens" and generally refers to the exposure metering system to sync the flash unit to the camera.

Tripod: A three-legged camera support. Bigger cameras, like a Mamiya RB67, require a stronger, heavier tripod to support the weight of the camera.

Umbrella Reflector: An actual umbrella that is lined with material (white, gold and silver), in which an electronic flash can be reflected. The resulting light can be directed at a model, producing varying degrees of softness and intensity.

Zoom Lens: A lens of variable focal lengths. For example a 100-200mm zoom lens has a focal length that can be changed any where between 100mm and 200mm.

Index

a
advance planning 25
all-inclusive pricing 22
architecture 63, 85

b
background 40, 48, 66, 69-70, 75, 77-78
back-up equipment 51
Bronica SQ 50

c
cable release 52
camera bag 52
camera room 64
camera selection 50
casually perfect candid 40, 42
charities 14
checking a location 71
children's portraits 22, 32
 camera room psychology 32
 younger children 33
 teenagers 35-37
client's home 83
clothing 26-31
composition 42, 48, 51, 64, 71-72, 75
contact sheets 93
consultations 22, 25, 28-29, 30, 44
contributing photographers 100-101
corporate casual portraits 43
Craft, Dennis 22-23, 42, 53, 78, 85, 100
creating your own style 40

d
design elements 29, 31, 89
DiCaprio, Bob 37, 80-83, 86-87, 100
digital projection 96
displays 13-14, 21, 44

e
enlargements 50
equipment lists 51-53

f
family portraiture history 5-6
family portraiture today 6-12
fill flash 77, 79-80, 104
film 52
film backs 52
flash unit 51, 81
foreground 44, 49, 87-88, 90-92
formally posed portraits 44
fundraisers 14, 19

g
Goldsmith, Jay 10, 29, 31, 39, 44, 96, 100

h
Hasselblad cameras 50, 67
high key 64-65
holiday home tours 24
Holmes, Charla 19-21, 56, 60, 100
Holmes, Horace 6, 32-34, 66-67, 101

i
institutional ads 13

l
large format cameras 50
lenses 51
light
 available 79, 104
 fixed 64
 metering 52, 67, 72, 81
lighting
 background light 64, 67
 fill light 55, 64, 67-69, 72, 80, 92
 hair light 64, 67, 79
 kicker light 69, 105
 separation light 66
 techniques 68
Lilley, Ed 6, 21-22, 30, 43, 67-68, 79-80, 101
location 6, 25, 29, 44, 52-53, 71-82
low key 64-66

m Madearis, Roy 29, 43, 61-65, 81-82, 101
Mamiya RB67 50
marketing 13-17
medium format cameras 50
merit prints/projects 15-17

o opaque projectors 93

p paper previews 93
personality 38
photographing at the client's home 83-92
photographing on location 71-82
portrait psychology 32
posing styles
 casual comfortable 42
 casually perfect 40
 corporate casual 43
 fomally posed portraits 44
 relaxed formal 44
practice sessions 15
presentation options 93-97
 contact sheets 93
 digital projection 96
 finished product 97
 opaque projectors 93
 paper reviews 93
 slide proofs (transviews) 94
 video projection 95
products 97-99
promotion 13
 creative promotions 17-24
 Day in the Park promotion 19
 Portraits in the Park promotion 17
promotional sittings 17, 22
props 56-63

r relaxed formal portraits 44

s Schmidt, Michelle 17-18, 98, 101
slide proofs 94, 105
small format cameras 50
softbox 64, 68-69, 105
Spencer, Mark 47-48, 61, 69-70, 75
Straw, Marg & Peter 28-29, 44-46, 55, 75, 77, 97, 101
strobe unit 51-52, 80-81
studio portraits 64-70
 lighting for 64
 posing 64
sweet light 71

t Taylor, Randy 24, 48-49, 87-92, 94, 101
teenagers 35-37
telephone consultations 25
telephone inquiry 8
telephoto lens 52
today's family portraiture 6-12
transviews 94, 105
tripod 52-53, 105

u umbrella reflector 64, 87, 105

v video projection 95

w wall portraits 98-99
wedding photography 5-6
Whitmire, Ken 13, 48, 53, 98-99, 101
wide angle lens 52
working with different ages 32

y Yashicamat camera 50
younger children 33

Other Books from Amherst Media, Inc.

Basic 35mm Photo Guide
Craig Alesse

Great for beginning photographers! Designed to teach 35mm basics step-by-step — completely illustrated. Features the latest cameras. Includes: 35mm automatic and semi-automatic cameras, camera handling, *f*-stops, shutter speeds, and more! $12.95 list, 9x8, 112p, 178 photos, order no. 1051.

Camera Maintenance & Repair
Thomas Tomosy

A step-by-step, fully illustrated guide by a master camera repair technician. Sections include: testing camera functions, general maintenance, basic tools needed, basic repairs for accessories, camera electronics, plus "quick tips" for maintenance and more! $24.95 list, 8½x11, 176p, order no. 1158.

Don't Take My Picture
Craig Alesse

This is the second edition of the fun-to-read guide to taking fantastic photos of family and friends. Best selling author, Craig Alesse, shows you in clear, simple language how to shoot pictures, work with light, and capture the moment. Make everyone in your pictures look their best! $9.95 list, 6x9, 104p, 100+ photos, order no. 1099.

Camera Maintenance & Repair Book 2
Thomas Tomosy

Advanced troubleshooting and repair building on the basics covered in the first book. Includes; mechanical and electronic SLRs, zoom lenses, medium format, troubleshooting, repairing plastic and metal parts, and more. $29.95 list, 8½x11, 176p, 150+ photos, charts, tables, appendices, index, glossary, order no. 1558.

Build Your Own Home Darkroom
Lista Duren & Will McDonald

This classic book shows how to build a high quality, inexpensive darkroom in your basement, spare room, or almost anywhere. Information on: darkroom design, woodworking, tools, and more! $17.95 list, 8½x11, 160p, order no. 1092.

Restoring Classic & Collectible Cameras
Thomas Tomosy

A must for camera buffs and collectors! Clear, step-by-step instructions show how to restore a classic or vintage camera. Work on leather, brass and wood to restore your valuable collectibles. $34.95 list, 8½x11, 128p, b&w photos and illustrations, glossary, index, order no. 1613.

Into Your Darkroom Step-by-Step
Dennis P. Curtin

The ideal beginning darkroom guide. Easy to follow and fully illustrated each step of the way. Information on: equipment you'll need, set-up, making proof sheets and much more! $17.95 list, 8½x11, 90p, hundreds of photos, order no. 1093.

Big Bucks Selling Your Photography
Cliff Hollenbeck

A complete photo business package for all photographers. Includes secrets to making big bucks, starting up, getting paid the right price, and creating successful portfolios! Features setting financial, marketing and creative goals. This book will help to organize business planning, bookkeeping, and taxes. $15.95 list, 6x9, 336p, order no. 1177.

The Wildlife Photographer's Field Manual

Joe McDonald

The complete reference for every wildlife photographer. A practical, comprehensive, easy-to-read guide with useful information, including: the right equipment and accessories, field shooting, lighting, focusing techniques, and more! Features special sections on insects, reptiles, birds, mammals and more! $14.95 list, 6x9, 200p, order no. 1005.

Swimsuit Model Photography

Cliff Hollenbeck

A complete guide to swimsuit model photography. Includes: finding and working with models, selecting equipment, posing, props, backgrounds, and much more! By the author of *Big Bucks Selling Your Photography* and *Great Travel Photography*. $29.95 list, 8½x11, 112p, over 100 b&w and color photos, index, order no. 1605.

Infrared Photography Handbook

Laurie White

Covers black and white infrared photography: focus, lenses, film loading, film speed rating, heat sensitivity, batch testing, paper stocks, and filters. Black & white photos illustrate how IR film reacts in portrait, landscape, and architectural photography. $24.95 list, 8½x11, 104p, 50 b&w photos, charts & diagrams, order no. 1419.

Glamour Nude Photography

Robert and Sheila Hurth

Create stunning nude images! Robert and Sheila Hurth guide you through selecting a subject, choosing locations, lighting, and shooting techniques. Includes information on posing, equipment, makeup and hair styles, and much more! $24.95 list, 8½x11, 144p, over 100 b&w and color photos, index, order no. 1499.

The Art of Infrared Photography / 4ᵗʰ Edition

Joe Paduano

A practical, comprehensive guide to the art of infrared photography. Tells what to expect and how to control results. Includes: anticipating effects, color infrared, digital infrared, using filters, focusing, developing, printing, handcoloring, toning, and more! $29.95 list, 8½x11, 112p, order no. 1052.

Wedding Photographer's Handbook

Robert and Sheila Hurth

The complete step-by-step guide to succeeding in the exciting and profitable world of wedding photography. Packed with shooting tips, equipment lists, must-get photo lists, business strategies, and much more! $24.95 list, 8½x11, 176p, index, b&w and color photos, diagrams, order no. 1485.

Infrared Nude Photography

Joseph Paduano

A stunning collection of images with informative how-to text. Over 50 infrared photos presented as a portfolio of classic nude work. Shot on location in natural settings, including the Grand Canyon, Bryce Canyon and the New Jersey Shore. $29.95 list, 8½x11, 96p, over 50 photos, order no. 1080.

Lighting for People Photography

Stephen Crain

The complete guide to lighting. Includes: set-ups, equipment information, how to control strobe and natural lighting, and much more! Features diagrams, illustrations, and exercises for practicing the lighting techniques discussed in each chapter. $29.95 list, 8½x11, 112p, b&w and color photos, glossary, index, order no. 1296.

Black & White Nude Photography

Stan Trampe

This book teaches the essentials for beginning fine art nude photography. Includes info on finding your first models, selecting equipment, scenarios of a typical shoot, and more! Includes 60 photos taken with b&w and infrared films. $24.95 list, 8½x11, 112p, index, order no. 1592.

Handcoloring Photographs Step-by-Step

Sandra Laird & Carey Chambers

Learn to handcolor photographs step-by-step with the new standard handcoloring reference. Covers a variety of coloring media. Includes colorful photographic examples. $29.95 list, 8½x11, 112p, 100+ color and b&w photos, order no. 1543.

Special Effects Photography Handbook
Elinor Stecker Orel

Create magic on film with special effects! Little or no additional equipment required, use things you probably have around the house. Step-by-step instructions guide you through each effect. $29.95 list, 8½x11, 112p, 80+ color and b&w photos, index, glossary, order no. 1614.

Lighting Techniques for Photographers
Norm Kerr

This book teaches you to predict the effects of light in the final image. It covers the interplay of light qualities, as well as color compensation and manipulation of light and shadow. $29.95 list, 8½x11, 120p, 150+ color and b&w photos, index, order no. 1564.

Achieving the Ultimate Image
Ernst Wildi

Ernst Wildi shows how any photographer can take world class photos and achieve the ultimate image. Features: exposure and metering, the Zone System, composition, evaluating an image, and much more! $29.95 list, 8½x11, 128p, 120 B&W and color photos, index, order no. 1628.

Computer Photography Handbook
Rob Sheppard

Learn to make the most of your photographs using computer technology! From creating images with digital cameras, to scanning prints and negatives, to manipulating images, you'll learn all the basics of digital imaging. $29.95 list, 8½x11, 128p, 150+ photos, index, order no. 1560.

Black & White Portrait Photography
Helen T. Boursier

Make money with B&W portrait photography. Learn from top B&W shooters! Studio and location techniques, with tips on preparing your subjects, selecting settings and wardrobe, lab techniques, and more! $29.95 list, 8½x11, 128p, 130+ photos, index, order no. 1626.

Profitable Portrait Photography
Roger Berg

Learn to profit in the portrait photography business! Improves studio methods, shows lighting techniques and posing, and tells how to get the best shot in the least amount of time. A step-by-step guide to making money. $29.95 list, 8½x11, 104p, 120+ B&W and color photos, index, order no. 1570.

Amherst Media's Customer Registration Form

Please fill out this sheet and send or fax to receive free information about future publications from Amherst Media.

CUSTOMER INFORMATION

DATE

NAME

STREET OR BOX #

CITY STATE

ZIP CODE

PHONE () FAX ()

OPTIONAL INFORMATION

I BOUGHT *FAMILY PORTRAIT PHOTOGRAPHY* **BECAUSE**

I FOUND THESE CHAPTERS TO BE MOST USEFUL

I PURCHASED THE BOOK FROM

CITY STATE

I WOULD LIKE TO SEE MORE BOOKS ABOUT

I PURCHASE [] BOOKS PER YEAR

ADDITIONAL COMMENTS

FAX to: 1-800-622-3298

Name_____
Address_____
City_____State_____
Zip_____ — _____

Amherst Media, Inc.
PO Box 586
Buffalo, NY 14226